LOST
PUT-IN-BAY

LOST
PUT-IN-BAY

WILLIAM G. KREJCI

THE
History
PRESS

Published by The History Press
Charleston, SC
www.historypress.com

Front cover: Delaware Avenue, Put-in-Bay, Ohio, 1906. *Library of Congress*.
Back cover: Perry's Victory and International Peace Memorial on a misty morning, 2018. *William G. Krejci*.
Back cover, inset: The Perry Willow, 1898. *Library of Congress*.

First published 2022

ISBN 978-1-5402-5242-5

ISBN 978-1-4671-4740-8

Library of Congress Control Number: 2022933421

Notice: The information in this book is true and complete to the best of our knowledge. It is offered without guarantee on the part of the author or The History Press. The author and The History Press disclaim all liability in connection with the use of this book.

For island friends…past, present and beyond.

CONTENTS

Contents

ACKNOWLEDGEMENTS

I would like to extend a special thanks to Dan Savage, Cindy Clausen and everyone at the Lake Erie Islands Historical Society Museum for their priceless contributions toward making this book a reality. Furthermore, special thanks go to Phillip Boyles and Arthur Boyles for their wonderful assistance and use of their photos. Thank you to Andrea Lee and Bob Gatewood at AB Rentals for their contributions to the section on the Bashore. Thanks to Sean William Koltiska, Bobby Hill and Autumn Therese Taylor for assisting me in gathering many pictures. A big thank-you to Viktoriya Zakharova, who has a great love of island history. I would also like to extend my gratitude to Jeff and Kendra Koehler, Dustin Heineman and everyone at Heineman's Winery, Chip Duggan, Peter Huston, Susan Cooper, Michael Gora, John Rodrigue, Hilary Parrish, Caroline Rodrigues and the staff at The History Press, Rutherford B. Hayes Presidential Library and Museums, the Alpena County George N. Fletcher Public Library, Danny Drake and the Getaway Inn at Cooper's Woods, Put-in-Bay Yacht Club, George and Mary Krejci, Perry's Victory and International Peace Memorial, the Library of Congress and Wikimedia Commons.

Chapter 1

A HISTORY LOST AND FOUND

WELCOME TO PUT-IN-BAY

Put-in-Bay, a village on Lake Erie's South Bass Island, draws hundreds of thousands of visitors each year. Some come to experience the vibrant night life, while others are drawn by the many family-friendly attractions. All, it seems, are seeking a getaway from the monotonous routines of the everyday world. Put-in-Bay doesn't disappoint. While the island boasts a famously known party atmosphere, so much lies beyond. There are caves and nature trails to explore. Jet skis and kayaks are available for rent. Island tours and even a village ghost walk may be enjoyed. Put-in-Bay's crowning jewel, without a doubt, is Perry's Victory and International Peace Memorial, a national monument that towers 352 feet above the island.

With all that the island has to offer, there must be a rich history to accompany such a location. Put-in-Bay doesn't disappoint in this regard either. The generally accepted history of the island reads thus:

In the early 1800s, the island was purchased by a judge named Pierpont Edwards. Land was cleared and farming commenced, but the early settlers were driven off by Indians shortly after the declaration of the War of 1812. In the summer of 1813, Commodore Oliver Hazard Perry used the island as a staging point for the Battle of Lake Erie, a celebrated victory for the United States Navy over the British, which occurred on September 10 of that year.

Upon the conclusion of the War of 1812, settlers returned to the island. Among them were Captain Hill and a man named Asahel "Shell" Johnson. Both stayed for only a few years. Also residing on the island was a man named Ben Napier, a squatter with a reputation for being a pirate, who was driven from the island. These men were followed by the Hyde family, who remained on the island into the early 1830s. During the 1840s, Phillip Vroman settled on the island as a caretaker for the Edwards family.

In 1854, the island was sold to Joseph de Rivera, a wealthy Spanish merchant, who bought a number of the islands for $44,000. Not long after, de Rivera had South Bass Island surveyed and divided into ten-acre lots, which he sold to the public. The village of Put-in-Bay was established in 1877.

That's the short, and slightly inaccurate, version. Herein follows the story that, until now, has been largely overlooked and only recently rediscovered.

THE EARLIEST ISLAND RECORD

Without a doubt, the earliest inhabitants of South Bass Island were the Indigenous people who predate European American settlement. The noted frontiersman Colonel James Smith mentioned the Bass Islands in an account made in the autumn of 1757. That year, he'd been on a hunting expedition in the company of Tecaughretanego, the great Caughnawaga chief, and his people. A council was held at the mouth of the Detroit River on November 1, and the company contemplated crossing Lake Erie, either by holding to the western shoreline or by means of "the three islands." While Smith stated that these islands were seldom visited, owing partially to the dangerous abundance of rattlesnakes, he claimed that the Wyandot and Ottawa occasionally made their winter hunts there to fish the surrounding waters, hunt fowl and trap raccoon.

It's a fact that the islands were once so populated with rattlesnakes that a detailed map of Lake Erie, made between 1760 and 1763, refers to the Bass Islands by their earliest recorded name: Les Isles aux Serpente Sonnette (or Les îles aux Serpent Sonnette), which translates to the "Rattlesnake Islands." Though not one of the Bass Islands, today's Rattlesnake Island exists as the final vestige of this early designation, despite legends that claim it received its name due to its shape, which doesn't resemble a snake in the least. Sadly, the eastern Massasauga rattlesnake (*Sistrurus catenatus*), for which these islands

were so named, is now extinct from the Lake Erie Islands region, which is great for tourism but unfortunate for the snake.

Another claim that has resurfaced time and again is the idea that Put-in-Bay was originally called "Pudding Bay." These assertions state that a map, dating to 1784, indicates the island being called Pudding Bay. It was speculated that it received this name owing to the shape of the bay, which "resembled a pudding sack," or that it was in reference to the muddy bottom that resembled pudding. In fact, no map makes reference to Pudding Bay until 1814, and by then, the name Put-in-Bay was well established.

One of the earliest accounts of the name Put-in-Bay comes from a journal kept by Lieutenant Isaac Anderson during the American Revolution. Anderson was born in Donegal, Ireland, and, following the deaths of his parents, immigrated to the Pennsylvania Colony. Soon after the commencement of the Revolutionary War, he enlisted with the Continental Army and before long rose to the rank of lieutenant. In the summer of 1781, he took command of a company of the Westmoreland County, Pennsylvania Militia and was sent to join an expedition against the Indians along the Ohio River. Having been captured by them on August 24, he was marched to Detroit. On November 4, he was placed on board the sloop *Felicity* and sent east to the Niagara River. On November 5 and 6, owing to unfavorable winds, the *Felicity* laid at anchor at Put-in-Bay, so named in his journal.

THE FIRELANDS

Composed of land that would become northeast Ohio, the Connecticut Western Reserve was established in 1786 and was opened to settlement shortly thereafter by the Connecticut Land Company. Still, the land west of the Cuyahoga and Tuscarawas Rivers remained Indian Territory until the signing of the Treaty of Fort Industry on July 4, 1805. At this, the Wyandot, Munsee and Delaware nations, and those of the Shawnee and Seneca nations who resided with the Wyandots, were to receive $1,000 annually in perpetuity. The Ottawa, Chippewa and those Potawatomi who resided along the Huron River received a total of $16,000. By this treaty, all continued to retain the right to hunt and fish the land.

Thus it was that the Firelands were established on the northern portion of those lands west of the Cuyahoga. They were so named because the land was intended to be made available to those farmers who were burned

A woodcut portrait of Judge Pierpont Edwards, dated 1783. *Wikimedia Commons.*

out by the British during the Revolutionary War. Settlement of the region commenced around 1808. The previous year, a draft was held, at which time the land was divided up among the Connecticut Land Company's investors. Among these investors was Judge Pierpont Edwards.

Pierpont Edwards was born in 1750 in Northampton, Massachusetts. By 1771, he had relocated to New Haven, Connecticut, and set up a practice as an attorney. During the American Revolution, he served in the Continental Army and also was a member of the Connecticut House of Representatives. In February 1806, he was nominated by President Thomas Jefferson to the United States District Court and served as a federal judge until his passing in 1826. In 1769, he was married to Frances Ogden. They were the parents of eleven children.

Judge Edwards was not only an investor but was also a founder of the Connecticut Land Company and owned approximately one-twentieth of the Western Reserve. In the draft of 1807, Judge Edwards was granted Township Number 7 in the 16th Range of Townships. Today, this land exists as the cities of Avon and Avon Lake. The northern end of this township, that which makes up Avon Lake, exists as a blunt peninsula jutting into Lake Erie. Each township was to consist of twenty-five square miles. Due to its irregular shape, this one fell short. At this, Judge Edwards was granted a number of the Lake Erie islands, including South Bass Island, for the purpose of equalization.

Aside from the Ottawa and Wyandot, who occasionally wintered on the islands, South Bass also hosted numerous French fur trappers. On occasion, the remains of some of these early island visitors, who died and were laid to rest along the island's shore, are discovered and reinterred in the island's Maple Leaf Cemetery, where they now take their repose with dignity and respect.

BASS ISLAND COTTAGE

A story that calls to mind the island's earliest habitation by European Americans, titled "Bass-Island Cottage," was written by Benjamin Drake and first appeared in the *Cincinnati Literary Gazette* on January 1, 1824. This story has the distinction of being the first western short story written by a western author.

The teller of this tale appears as a soldier in the U.S. Army, which was encamped at Put-in-Bay in the days following the Battle of Lake Erie in September 1813. The narrator describes a dilapidated wooden cottage, covered in ivy, located above a gradual descent to the margin of the bay. The home, by all appearances, had long been abandoned. Its doors were broken down and the roof fallen in.

Days later, the army having crossed the lake and taken control of Fort Malden on the Canadian shore, the storyteller describes meeting a man who was familiar with the ruins on South Bass Island. He furnished the narrator with a small pocket manuscript that he procured from the family physician of the cottage's former occupants.

The body of the text speaks of an Englishman named Charles Lovell, who with his wife, Mary, took up residency on the isolated isle. Though the reasons are not divulged, Lovell appeared to be attempting an escape from the memories of some past tragedy. Within a year of relocating to the island, Charles and Mary Lovell were blessed by the birth of a son.

One June day, three years into their residency on South Bass Island, the small family took a sailing excursion on the lake. That afternoon, a tempest picked up, and the family was lost to the ever-unpredictable waters of Lake Erie. From that day forward, the small island cabin lay abandoned.

It's appropriate to conclude that this might simply be a romantic legend. And why not? The islands are rich with these. Still, the description of the island at that time was fairly accurate. It's a strong possibility that Benjamin Drake interviewed such a soldier as the one described as being the narrator when penning this tale. The cottage in question might very well have existed, and the story might in fact have been based on a real-life experience.

EDWARDS' CLEARING

In 1810, Judge Pierpont Edwards deeded his Lake Erie Island holdings to two of his sons, John Starke Edwards and Moses Ogden Edwards, who preferred the use of his middle name. Almost at once, plans were made for settlement of the island. Pivotal to these plans was a twenty-six-year-old Cleveland man named Seth Doan.

In 1798, when only thirteen years of age, Doan had been sent by his father from Connecticut to Cleveland to live with his uncle Nathaniel. It's said that this was to prevent the lad from giving in to the temptation of embarking with a whaling ship or sailing abroad on some expedition to the Indies. Shortly after arriving in Cleveland, the entire settlement contracted malaria. Also ill, but suffering less than the others, was young Seth. It fell upon this boy to care for the entire settlement of Cleveland and see them through illness, hardship and starvation to recovery.

In 1811, under the instruction of John Starke Edwards, Seth Doan set out for South Bass Island with 150 sheep, 400 hogs and thirty-two people composing seven families. Upon arrival, they discovered and forcibly removed the French fur trappers who were encamped there. They set themselves to the task of clearing roughly one hundred acres on the north shore of the island along the verge of the bay. Known as Edwards' Clearing, this later became the site of the Village of Put-in-Bay. The settlers planted wheat that fall and brought in a late harvest of two thousand bushels, most of which was sent over to present-day Catawba Point for storage in a log house.

THE FALL OF THE ISLAND SETTLEMENT

The following June, the United States declared war on Great Britain, and within weeks, the War of 1812 had its grip on the region. That summer, Fort Detroit was surrendered by General Hull to the British. Aiding the British in this conflict was the Shawnee leader Tecumseh and his Confederation of Native Americans.

After the fall of Detroit, a number of men from Tecumseh's Confederation arrived at Put-in-Bay and chased off the island's settlers. The wheat was burned in the field, as was the store on Catawba Point, and the sheep and hogs that were brought to the island were turned loose. The thirty-two island

settlers set off in boats and crossed the lake, arriving at the mouth of the Vermilion River just before nightfall.

Operating a tavern, hotel and trading post on the east bank of the Vermilion River's outlet onto Lake Erie were Frederick Barlow Sturges and his twenty-year-old wife, Charlotte. At the time of the attack on Put-in-Bay, Frederick was away at the mill at Ruggles' Tavern, leaving Charlotte to mind the tavern with their two-year-old daughter, Eunice. There were no guests staying at the hotel at the time, thus leaving the small family quite alone. Having received word of the fall of Detroit, Mrs. Sturges was in a state of anxiety at the prospect of a similar attack being made on Ohio's little shoreline settlements.

It was evening when Charlotte Sturges first noticed the approaching boats, silhouetted against the setting sun. Not being able to discern if they were British, Americans or Indians, she feared the worst. The boats proceeded up the river just after sunset and made landfall at a nearby marsh. It was quite dark when they approached the Sturges place. Charlotte Sturges, who had readied herself with firearms, almost shot the approaching strangers. At the last moment, she was able to distinguish voices that recognized the place as a tavern and announced that they were seeking aid and shelter. The refugees were admitted at once.

The party from Put-in-Bay remained at Sturges' Tavern for five days. During that time, Frederick Sturges returned and other settlers in the area were alerted to what had transpired on the island. On the morning of the sixth day, a small party of men boarded boats and set out to survey the island to see what could be done about reclaiming the land. They made landfall on the island and, without being detected, quietly observed the men of Tecumseh's Confederation who had taken up occupancy of the cabins. That night, the raiders returned to Vermilion with a report of what they'd witnessed.

The following morning, with more men and muskets, the party returned to the island and attacked Tecumseh's men. After killing a number of them, they succeeded in driving the rest from the island. The party ultimately returned to Vermilion and decided it best for the settlers not to return to Put-in-Bay, owing to their exposure to future attacks.

In January 1813, John Starke Edwards set out with two men, George Parsons and William Bell, to survey the damage that had been done the previous summer to the settlement at Put-in-Bay. Edwards took ill near Sandusky, and an attempt was made to bring him home to Warren, Ohio. He died near Huron on January 29, 1813. George Parsons returned the

body to Warren, where interment was made in the Old Mahoning Cemetery that February. With the death of his brother, control and the responsibility of development of the island now fell to Ogden Edwards.

THE BATTLE OF LAKE ERIE

By the summer of 1813, military control of the Old Northwest between the United States and British armies had reached a stalemate. It was clear that whoever controlled the lakes would ultimately gain the upper hand in the war. By early 1813, the British had manned a squadron of fighting vessels on the upper lakes. To rival that squadron, the United States Navy constructed its own fleet of vessels at Erie, Pennsylvania. Command of that fleet was given to Master Commandant Oliver Hazard Perry, who assumed the role of commodore. That August, the American squadron was complete and made sail for Put-in-Bay.

By placing these vessels at Put-in-Bay, Commodore Perry successfully severed the supply lines to the British across the lake at Fort Malden in Amherstburg, Ontario. With only one day's rations remaining, the British were forced to set sail, make for Put-in-Bay and challenge the Americans.

In the early morning hours of September 10, 1813, the British sails were sighted to the northwest beyond Rattlesnake Island. Perry's squadron weighed anchor and set out to meet them. Progress for the American fleet was slow, owing to a steady southwest wind. After two hours of tacking, the wind shifted to the southeast, ultimately giving Perry the advantage and the favorable wind, called the weather gauge.

The battle commenced shortly before noon, and after nearly three hours of fighting, and miraculous circumstances, the American squadron proved victorious. Further details of this famous naval engagement may be found in the many books written on the subject or by checking out the visitors' center at Perry's Victory and International Peace Memorial.

Those enlisted men who were killed in the battle were stitched up into their hammocks, with a cannonball placed at their feet, and their bodies committed to the deep to await the resurrection, when the sea shall give up her dead. Tradition held that officers were to be buried on land. Commodore Perry stuck to this tradition. Three American and three British officers were killed in that engagement. Rather than burying them in separate respective burial sites, Perry chose to inter these men together

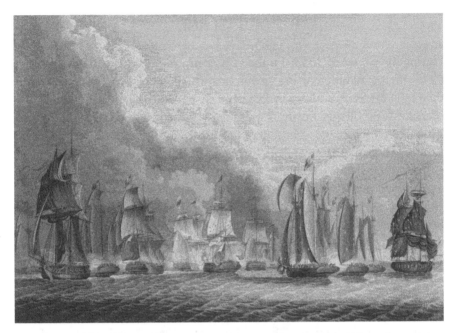

A woodcut engraving dated July 26, 1815, depicting the Battle of Lake Erie on September 10, 1813. The caption reads: "This representation of the *Battle of Lake Erie* is respectfully inscribed to *Commodore Perry*, his officers, and gallant crews. By their humble servant, *James Webster*." *Wikimedia Commons.*

in one mass grave as equals. It is said that, following this burial, Perry walked to the verge of the bay and snapped off a branch from a green willow tree. He marked the burial site with that branch, which took root and became a willow tree of its own. Another story claims that it was a green willow walking stick that was planted by a man from Vermilion who visited the island shortly after the battle. Called the Perry Willow, sometimes referred to as the Lone Willow, that tree marked the officers' burial site for the next eighty-seven years until it fell in 1900. Curiously, an account of the burial site in 1820 makes no mention of a tree, willow or otherwise. It simply states that the "ordinary tumuli that designate graves are to be seen, but neither monument nor gravestone marks the spot where the poor fellows lie." This suggests that the willow might have been an afterthought and might not have been as old as first believed.

ROSS ISLAND

During the winter of 1813–14, the U.S. Army and Navy maintained a small force on the island. Further details regarding these operations following the battle are covered later in this book. It is said that, following the Battle of Lake Erie, Ogden Edwards sought out someone to take on the role of caretaker of the island. That caretaker was found in James Ross of Centre County, Pennsylvania.

Ross was called up by the Pennsylvania Militia in March 1813. He served as a private in Captain George Record's Company of Colonel Rees Hill's 147th Regiment. His company arrived in Erie on April 20 and was assigned to guard the construction of Commodore Oliver Hazard Perry's fleet, which was being built in that town.

As the construction of Perry's naval squadron was nearing completion and his term with the militia reaching a close, Ross volunteered to go aboard Perry's fleet on July 25. He was stationed aboard the schooner *Scorpion*, which was commanded by Perry's cousin, Sailing Master Stephen Champlin. That vessel had the distinction of firing the first and last American shots of the engagement and captured the British vessels *Chippewa* and *Little Belt*.

Following the battle, and with the terms of his service in Perry's squadron drawing to a conclusion, James Ross was in contact with Ogden Edwards. Edwards hoped to reestablish a settlement on the island but needed a new caretaker. James Ross fit the bill. Thus, James Ross remained at Put-in-Bay.

For the next few years, Ross resided on South Bass Island. For a time, the island on the whole was even referred to by passing sailors as Ross Island. That name was ultimately applied only to a small islet at the southeast edge of Squaw Harbor. This islet was eventually connected to the main part of the island by fill and today exists as a small landing at Miller Marina that boasts a grassy area and a pavilion.

Another person claimed to have resided on the island was a man referred to simply as Captain Hill. It turns out that this man was Daniel Hill, who also had the distinction of having served under Perry at the Battle of Lake Erie. He returned to the island upon the war's conclusion in 1815 and there built a cabin. Further details on Captain Daniel Hill, his extraordinary life and that cabin are covered later in this book in the section on Hill's Tavern.

On June 17, 1816, the British brig *Tecumseh* was at anchor at Put-in-Bay. It stopped an American merchant vessel, the schooner *Ranger*, while passing the islands. An affidavit was sworn by the junior commander, Shadrach Penn, that while passing the island, the crew of the *Ranger* heard the sound

of musket fire coming from what is now Peach Point. The crew, thinking this a distress signal, came about and approached the bay. At this, the *Tecumseh* weighed anchor and sailed out to meet the approaching schooner. The commander of the *Tecumseh*, a lieutenant named Kent, forced his way aboard and interrogated the crew of the *Ranger* regarding their business, cargo and complement of crew. When asked about the source of the gunfire, Lieutenant Kent dismissed it as "nobody, but some Indians." The crew believed this a false statement.

The previous fall, a British armed schooner, the *Nawash*, under the command of a Lieutenant Drury, fired on and similarly stopped a U.S. merchant schooner called the *Mink*. It was rumored that the British had a total of seven armed vessels on Lake Erie and were building an eighth at Fort Malden.

The presence of armed British vessels, and the unscrupulous activities of their commanders, on the waters near Put-in-Bay was quite unsettling for those few people residing on the island. The War of 1812 being only recently concluded, there still existed an uneasy peace. The situation was remedied in April 1818 with the ratification of the Rush-Bagot Agreement, which limited the number of armed naval vessels on the Great Lakes and ultimately led to complete disarmament. This treaty, the shortest between nations, is still in effect today.

On May 29, 1817, Ogden Edwards placed an advertisement offering advantageous terms to people willing to settle on the island. Settlement was slow, being limited to a caretaker and only a couple of families. Even at that, a new caretaker would need to be found within the year.

James Ross died on August 11, 1817, and was laid to rest just below the high point at the eastern end of Gibraltar Island, called Perry's Lookout. A conflicting report claims his date of death being July 11. Another man named John Elliot followed him to the grave on September 18 of that year and was interred beside him. No cause of death can be located for either man. It's unknown who exactly John Elliot was. Unlike Ross, his name is not among those who fought at the Battle of Lake Erie.

Both graves were marked by headboards—not headstones, but pieces of wood that had these men's vital information painted on them. An article that appeared in the *Sandusky Register* on June 15, 1863, attempted to poetically describe this burial site. Unfortunately, by that point, most of the information painted on the headboards had been worn away with time, and the author incorrectly listed their year of death as 1848. Many years later, both headboards lost to the ravages of time, James Ross's burial site

was marked with a headstone that bore his correct date of death. Sadly, for reasons that remain unknown, this headstone was removed, and the site is now unmarked.

It was supposed by some that the James Ross who fought in the Battle of Lake Erie returned to Pennsylvania after that engagement and was married in 1814 to a woman named Betsey McElhattan. While this James Ross did serve in the Pennsylvania Militia during the War of 1812, his descendants claim that he served in the 135th Regiment (Christy's) while the James Ross who served under Perry was attached to the 147th Regiment (Hill's).

Not long after the passing of John Elliot, the island was visited by the schooner *Firefly* under the command of a Captain Hammond. Also on board were two officers of the 5th U.S. Regiment from Massachusetts, which at that time was stationed in Detroit. Their mission was to exhume the remains of Marine Lieutenant John Brooks Jr., who was killed at the Battle of Lake Erie, and return the body to Detroit, where it was to be buried with honors at Fort Shelby. That October, an excavation of the officers' burial site was made. Human remains were disinterred and loaded onto the *Firefly*. These remains were buried with full military honors in the new military burial ground on the glacis at Fort Shelby in Detroit on October 31, 1817.

RESETTLEMENT

In early 1818, new caretakers for Put-in-Bay were found in Henry and Sarah "Sally" Hill Hyde. The Hydes made the trip to the island that spring from New York with their four children. On their arrival, they took up residency with Captain Daniel Hill and his family. The strongest evidence suggests that Sally Hyde and Daniel Hill were first cousins, though that connection cannot yet be absolutely confirmed.

In the summer of 1818, a man named William Darby took a trip from New York City to Detroit. That August, he sailed on Lake Erie and passed through the Bass Island archipelago. After making this trip, he wrote an account of South Bass Island and described Edwards' Clearing. He incorrectly stated that the Bass Islands were uninhabited. Unfortunately, due to a strong west wind, he was unable to make landfall at Put-in-Bay. Had he done so, he would have found his claim of a lack of habitation was otherwise.

On July 13, 1819, the island was visited by the *Walk-in-the-Water*, the first steamboat to ply the waters of Lake Erie. It stopped at Put-in-Bay to

take on cordwood for the boiler. While there, some of the passengers, who were bound from Buffalo to Detroit, thought to explore the island. In doing so, they located a cavern near the center of the island and entered. Upon reaching the bottom, they found themselves in a massive chamber with an underground lake at the back. This is one of the earliest accounts of what became known as Perry's Cave. The only other account that predates this comes from Samuel Hambleton, purser for Perry's squadron, who visited the cave in the summer of 1813.

By 1820, the island was inhabited by yet another family, the Johnsons. Sheldon Johnson (not Shell or Asahel, as has been previously claimed) was born in Derby, New Haven County, Connecticut, on June 21, 1784. During the War of 1812, he captained a vessel that transported supplies from foreign countries to aid the U.S. Army. In 1814, he was captured by the British, and his vessel and cargo were confiscated. He was first married in 1813 to Clarinda Dodge, who died two years later while giving birth to their son Lawrence. Not long after, he married Martha Mason, a descendant of Puritans from the original Massachusetts Bay Colony. Their daughter, Jane, was born at Put-in-Bay on December 19, 1820. The following July, the Johnsons' house was mentioned in the journal of Major Delafield, who was visiting the island on a surveying trip. He stated that their house was located near the burial site of the officers who died at the Battle of Lake Erie. This would make their house the cabin that was once located near the current site of the Doller Building.

By 1823, the Johnsons were living on the mainland in Brownhelm Township in Lorain County. A few years later, they relocated to Dover Township, Cuyahoga County, Ohio. Today, this is the city of Westlake. Sheldon Johnson died on January 26, 1866, and takes his repose with his family at Maple Ridge Cemetery in Westlake, Ohio.

On November 20, 1829, an article appeared in the *New York Spectator*, which detailed a letter to the Buffalo Museum dated October 25. The author wrote about his experiences on a visit to Put-in-Bay, where he and some friends came to explore the caves. On the island, they took their lodging at the home of Henry and Sally Hyde, whom he claimed had lived there for the last twelve years. The author commented at length on the beauty of Henry and Sally Hyde's two elder daughters, those being twenty-one-year-old Harriet and twenty-year-old Sally. He observed, "Were they transplanted to the metropolis of the nation, they would be the very butterflies of the gay world."

On the night of Saturday, August 15, 1830, the packet *Lafayette* was voyaging from Ballast Island to Put-in-Bay but was met with foul weather. Heavy seas drove the vessel into the rocks at East Point, where it was wrecked. The

crew of five persons, including the captain, Benjamin A. Napier, survived by climbing the twenty-foot cliffs to safety.

Ben Napier's name has come up before. It's been said in previous histories that he was a French Canadian squatter, living illegally on South Bass, who had claimed absolute ownership of the island and had been ejected by the Edwards family. Another claim is that he served with Commodore Perry and distinguished himself at the Battle of Lake Erie. Historic investigations reveal a very different story.

According to family records, Benjamin Arliss Napier was born in Scotland in 1790. He wasn't of French Canadian parentage, as stories suggest. His father, Robert Napier, was a native of Scotland, while his mother, Ann Arliss, hailed from Lincolnshire, England. Benjamin Napier was described by one who knew him well enough as being a man with a giant frame and "a will as indomitable as that of Napoleon, and a spirit when aroused, as turbulent as the storm lashed lake."

After moving to the United States, he made his way west and became a merchant sailor. During the summer of 1812, while working for Captain Daniel Dobbins aboard the *Salina*, he was captured by the British at Fort Michilimackinac but was paroled. Being angered at his mistreatment by the British, he joined the U.S. Army, serving as a private in Captain John Reed's Company during the War of 1812. Despite the claims of some, he was not a participant at the Battle of Lake Erie, nor is he the white-haired man with white bushy sideburns who is depicted in William Henry Powell's portrait of that famous engagement. The men who modeled for that painting were sailors who worked at the Brooklyn Navy Yard in New York in the 1860s. Following the War of 1812, Napier took up residency with his wife, Erepta Landon, in Ashtabula County and raised many children.

During his long career as a sailor, Napier served as master and captain of many vessels on Lake Erie, which, aside from the *Lafayette*, included the *Farmer*, *Telegraph*, *DeWitt Clinton* and *Zephyr*. Following the wreck of the *Lafayette*, he purchased a sloop called the *Atlas*.

In truth, no evidence exists to support stories that Benjamin Napier was ever a squatter on South Bass Island. It's claimed that he had been living undisturbed in a cedar cabin on the island through the 1820s and into the early 1830s. This wouldn't have been so, as there were others residing at Put-in-Bay who were agents of the Edwards family, who would have removed him from the island if he had made claims of absolute ownership.

A claim of ownership was, however, made on Kelleys Island, which at the time was called Cunningham's Island. Datus and Irad Kelley, who

had purchased the island legally from its rightful owner, had difficulty in removing Napier. The court battle lasted a decade, and in the process, Benjamin Napier was forced to sell the *Atlas* to cover judgments against him. Eventually, he was removed from the island and relocated his family to Port Clinton. Finally, in April 1842, Napier was convicted of perjury in Sandusky and sentenced to five years in the penitentiary. This was for making false claims under oath regarding his ownership of Kelleys Island.

In September 1852, while visiting his seafaring sons Nelson and Joseph in Chicago, Benjamin Napier died of cholera. He was originally buried in the old Chicago City Cemetery, but that cemetery was redeveloped into Lincoln Park in the 1860s. At this, his remains were relocated to the City Cemetery in St. Joseph, Michigan, to take repose beside those of his son, Jack, who had accidentally been killed by an exploding cannon in 1859.

The year following Benjamin Napier's death, a fictionalized account, written by George S. Raymond, appeared in a Boston newspaper with the title "Ben. Napier, The Island Desperado." In this tale, "Old Ben Napier" is made out to be a pirate of the Lake Erie Islands. Interestingly, this is the first account of him ever having been a squatter at Put-in-Bay and appears to be the origin of that story. Otherwise, reports of him laying claim to Put-in-Bay didn't start circulating in newspapers until the 1880s.

November 11, 1830, saw the untimely death of Sally Hyde. Henry Hyde removed himself and their eight children to the mainland four years later and settled in the Port Clinton area.

In the spring of 1831, a forty-seven-year-old man named Sherman Pierpont took up residency at Put-in-Bay. He was a native of Connecticut and was the son of James Pierpont, a first cousin of Judge Pierpont Edwards, the island's original owner. Over the next two years, two docks were built by Sherman Pierpont, those being the West Dock, where South Bass Island State Park now stands, and the other located on the bay. That dock is now the site of the Boardwalk. A road that connected them, the only one on the island, later became Catawba Avenue. Any other thoroughfare that existed on the island was little more than a wooded path.

By 1834, Ogden Edwards had fallen on financial difficulties. That spring, he defaulted on a loan from Ebenezer Seeley, the former mayor of New Haven, Connecticut. On June 11, Seeley sued him, and Edwards was forced to forfeit some of his land, including a portion of his title to the islands. Two years later, his younger brother, Henry Alfred Pierpont Edwards, took ownership of the islands. A sheriff's sale was held, and the younger brother, who went by Alfred, secured the titles for $6,298. Obtaining the rest of the

title from Ebenezer Seeley was simple enough, as their wives, Deborah and Alice, were sisters. He purchased those shares for a mere $650.

Sherman Pierpont, who had been at Put-in-Bay for five years, decided to make the island his permanent home. On May 7, 1836, he departed Put-in-Bay with two men in a sailboat bound for Sandusky. He was on his way to Connecticut to collect his family and move them to the island. A squall kicked up on the lake and sank the vessel. Sherman Pierpont's body was recovered from the lake twenty days later and buried at Sandusky. A cenotaph memorializes his name in the Morris Burying Ground in Connecticut, where his family is interred. The remains of the two other men, whose names are unknown, were recovered from the lake near Marblehead in late June.

In 1836, the Manor House—also called the White House, owing to the fact that it was painted white—was built by Alfred Edwards. Other dates of construction that have been claimed are 1823 and 1834. If these dates were true, then the house would have been built by Ogden Edwards and not his brother Alfred, as is known to be fact. From most accounts, the Manor House stood two stories high and was the first frame house on the island, all others preceding it being of hewed cedar log construction.

In December 1839, Van Rensselaer Township was officially established, which included Catawba and South Bass Island. It was named for Philip Van Rensselaer, who served as agent for Alfred Edwards from 1838 to 1842. During that time, he also operated a store and trading post on the island.

THE VROMANS

The year 1843 saw the arrival of the next agent, foreman and caretaker of the island, that being Phillip Vroman, who was born in South Worcester, New York, on August 22, 1823. At the age of eighteen, he began sailing aboard a schooner on Lake Erie. Two years later, that schooner stopped at Put-in-Bay, which at that time was also being called Edwards' Island, to load cargo. While there, Phillip Vroman was introduced to Alfred P. Edwards, who took a liking to him at once. After a lengthy conversation, Edwards was successful in convincing Vroman to enter his employ. At first, he resided in a cabin near the bay and assisted Captain George McGibbon in running the sloop *A.P. Edwards*, which primarily hauled wheat from the island. Upon the death of McGibbon, Phillip Vroman was given command of that vessel until it was replaced by the steamer *Islander*. He was then engaged in loading

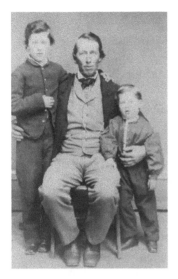

Early island settler Phillip Vroman posed for this portrait in 1858 with his sons Daniel (*left*) and Frank (*right*). *Courtesy of the Lake Erie Islands Historical Society Museum.*

operations at the two docks, where wood and stone were shipped from the island. In 1846, Phillip Vroman moved to the south side of the island, built a cabin and proceeded to clear land for a farm. He was married to Amelia Luce on May 2 of the following year. They became the parents of six children, four of whom lived to adulthood.

In July 1845, the island was briefly listed in an advertisement as being for sale by Alfred Edwards, though no price was attached to that ad. On February 20, 1847, Edwards again listed South Bass Island as being for sale. The ad boasted that the island had 250 acres under cultivation and vast growths of a variety of timber that could be used for steamboat fuel and ship construction. He stated that it contained inexhaustible quarries of limestone and the best harbor situated on the lake. The island also had a well-built home, that being the Manor House; five farmhouses in good order; several large barns; carpenter's shops; and blacksmith shops. It was further stated that the island was well stocked with cattle, cows, hogs and sheep. Also to be found were a great abundance of apple, peach and pear orchards. Again, a price was not listed in the advertisement. Three years later, a company from Thomaston, Maine, was erecting limekilns.

An incredible story was circulating in October 1849 that the island was boasting pumpkins of an enormous scale. The largest weighed 176 pounds. The pumpkins had been planted earlier that spring with seeds imported by Alfred Edwards from Chile. Interestingly, the art of growing massive pumpkins is a tradition that's still carried on by some island residents. The largest are presented at the island's annual Oktoberfest celebration.

In October 1851, Alfred Edwards advertised employment for quarry men and wood choppers to work on the island that winter. Also in 1851, Phillip Vroman stepped down as the island's agent to concentrate on his job as foreman. At this, a man named Archibald Jones was brought on to work as agent for Alfred P. Edwards. Archibald Jones was born in Petersburg, New York, on September 14, 1811. Of note, he was the fifth great-grandson of

Christopher Jones, master of the *Mayflower*. After working some years on the construction of the Erie Canal, he was married on April 15, 1835, to Sophie Needham. Upon accepting the position of agent for Mr. Edwards, he and his wife relocated to the island with their five children and remained until 1856, at which time they moved west.

In July 1853, Alfred Edwards placed Middle Bass Island up for sale. It was clear that he was ready to part with the islands for good. Rather than selling them, he opted for another solution. That summer, his twenty-one-year-old daughter, Alice Glover Edwards, was engaged to a man named Elisha Dyer Vinton. As a suitable gift, Edwards deeded the Lake Erie Islands to the couple, who were married that October.

The following year, Phillip Vroman moved himself and his family from the south shore of the island, where he'd resided since 1846, to the cedar cabin on the grounds of the Manor House that was previously occupied by the Hills and Hydes. Phillip Vroman's son Daniel soon became friends with Archibald Jones's son Frank, who also lived in the village and was a year younger than Daniel.

JOSEPH DE RIVERA ST. JURJO

It was clear from the start that Alfred P. Edwards's new son-in-law also had little interest in owning islands on Lake Erie. Almost immediately, he sought a buyer for the islands. That buyer, Joseph de Rivera, arrived on the scene in the summer of 1854.

José Maria los Dolores de Rivera St. Jurjo—or Joseph de Rivera, as he was mostly referred to—was born on March 20, 1813, in Barcelona, Spain. His parents, José de Rivera Y Burgos and Isabel Germandy Fernandez San Jurjo, were plantation owners in Loíza, Puerto Rico, and were visiting family in Spain at the time of their son's birth. His father died when young Joseph was only seven years old. At the age of thirteen, Joseph traveled to New York and shortly thereafter found employment as a representative for an importing firm in New York City. In time, he went into business on his own and eventually accrued a fair amount of wealth. He was naturalized as a U.S. citizen on October 17, 1838, with his friend Henry W. McCobb as his sponsor and witness. Two years later, Joseph de Rivera was married to Josephine Texidor of Guayama, Puerto Rico. They raised their family first in New York City and later in Bridgeport, Connecticut. His business broadened, and eventually

J. de Rivera & Company owned slate works in Vermont, a large property in Kentucky and a sugar plantation in the West Indies.

In 1854, de Rivera took a tour of the southern states with the intention of purchasing a plantation that he intended to staff with paid Spanish employees. Realizing the uproar this would cause among the slaveholding neighbors, he abandoned the plan and returned north. During his northbound trip, he was informed of the beauty of the Lake Erie Islands and that a number of them were up for sale. Arriving at Lake Erie at night, he chartered a small fishing boat at Lakeside to take him to the island. Upon landing at Put-in-Bay, he made his way to the Manor House, where he was given accommodations. The following morning, he was up with the sun. He strolled the island and walked the stony beach along the bay. He recalled in later years that it was a case of love at first sight.

Within forty-eight hours of arriving, Joseph de Rivera had purchased South Bass, Middle Bass, Ballast, Sugar and Gibraltar Islands for the grand sum of $44,000. The agent for this sale, acting on behalf of Alice and Elisha Vinton, was Eli Whitney Jr., the son of the noted inventor, who also happened to be Alice's first cousin. It should be an interesting note that Elisha Vinton didn't seem to be someone who held with sentiment. One might think that he wished to retain South Bass Island, seeing how that was the island that Commodore Perry used as his base of operations before and after his famous victory on Lake Erie, but this was not the case, even though the two were family. Oliver Hazard Perry's daughter, Elizabeth, was Vinton's aunt.

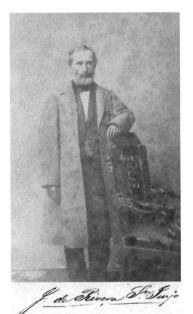

An 1858 portrait of early island owner Joseph de Rivera St. Jurjo with his signature below. *Courtesy of the Lake Erie Islands Historical Society Museum and the Library of Congress.*

At first, de Rivera used South Bass Island as a sheep farm and kept a herd of two thousand. Within a couple of years, he had disposed of the sheep and turned his attention to cultivating fruit, which proved a success. He had the island surveyed and divided into ten-acre lots and had roads laid out. He encouraged settlement of the island and the growing of grapes for wine production, which proved even more successful, owing to the late growing season.

Josephine Texidor de Rivera passed away in 1869 in Guayama, Puerto Rico. Two years later, Joseph de Rivera retired a millionaire. In 1875, he married Rachel Stokem of Connecticut, and in 1882, he permanently moved to Put-in-Bay. A few years later, his company, which he still retained interests in, failed, and he was stuck with many of the debts, which in the end left him almost penniless. Joseph de Rivera died on May 31, 1889, at Put-in-Bay and was laid to rest in a single vault in the island's Crown Hill Cemetery.

From early farming, cabin building, sparse settlement and endeavors at quarrying and raising livestock, to settlement on a grand scale and the cultivation of fruit and grapes, tourism would become the new draw to the island. The pioneer era of Put-in-Bay was soon to pass into history.

ACCOMMODATIONS

A PLACE TO STAY

Put-in-Bay is known for so many things. Among them are the fine hotel establishments that once graced the island. Take a step back in time and stroll the vast grounds of the island's luxuriously appointed accommodations. Unwind in the guest salons and suites. Dance the evening away in grand ballrooms and slumber in rooms dressed in gilded opulence.

FIRST PUT-IN-BAY HOUSE

As previously stated in the opening of this book, 1836 saw the construction of the Manor House, also referred to as the White House, by Alfred Pierpont Edwards. The first frame structure to grace the island, the property it sat on ran along the south side of present-day Delaware Avenue and was bounded by Catawba and Loraine Avenues. This home faced a grove of trees that later became DeRivera Park and the tranquil waters of the bay just beyond. In 1861, the Manor House was purchased by Joseph William Gray of Cleveland.

Joseph Gray was born on August 5, 1813, in Vermont but spent much of his boyhood on a farm in New York. In 1839, he came to Cleveland,

where he briefly worked as a schoolteacher. A year later, he completed his legal studies, was admitted to the bar and entered the law offices of Payne and Willson in Cleveland. On January 1, 1842, he and his brother, Admiral Nelson Gray, purchased the *Cleveland Advertiser* and, in the following issue, released the newspaper under the name of the *Cleveland Plain Dealer*. He was married in Cleveland in 1845 to Mary Katherine Foster, and they raised three children. In 1853, Joseph Gray was appointed postmaster of the city of Cleveland, a position he held until 1858. That year, he lost an eye and severely injured the other following an accidental discharge of a percussion cap on his son's gun. This left him mostly blind and unable to write. Though still greatly involved in the *Plain Dealer* as its editor, he turned his attention toward the islands.

The Manor House proved to be something of a project for Gray. It's been said that after purchasing the property, Gray did some renovations to the structure and reopened it for the summer of 1861 as a rooming house. It's unclear though whether he ever opened the Manor House for the accommodation of guests. This is looking more and more likely not to have been the case. The house is mentioned briefly in a July 1861 article in the *Cleveland Leader* that simply refers to it as "Mr. Gray's Mansion." It's described as being his island home, consisting of a little farm with grapevines and orchards. There's no mention of the place being used as a rooming house. Unfortunately, Gray's time spent on his island farm was brief.

Joseph Gray had been unwell for much of the following spring, though he was at his newspaper office regularly. On the night of Sunday, May 25, 1862, he suffered a stroke and passed away at 2:30 p.m. the following afternoon. He was initially laid to rest at Erie Street Cemetery in Cleveland on May 29 of that year but was exhumed and relocated to a mass grave in Highland Park Cemetery on March 22, 1907, when Erie Street Cemetery was being vacated, a project that was ultimately abandoned in 1918.

In 1864, the Manor House was sold by Joseph's widow, Mary, to Henry B. West, who had formerly served as Lorain County recorder. Henry West and his wife, Susan, settled onto the property and commenced with renovations of their own. The Manor House was opened for the 1865 season as the Put-in-Bay House, this being the first use of that name. The hotel also contained a store. The grounds were enclosed by a white picket fence.

The following year, West took on a partner named Amandar Moore. Like West, Moore had moved from Lorain County to Put-in-Bay. He worked as a lake captain and also as a deputy for the U.S. Customs House on the island. Captain Moore's involvement with the Put-in-Bay House was brief. He sold

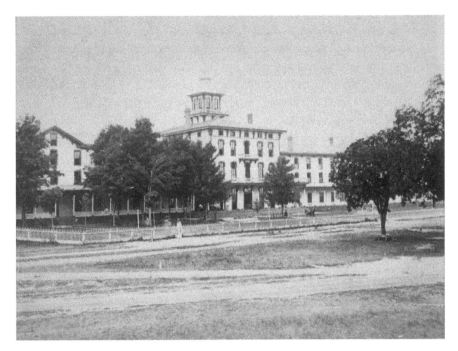

The first Put-in-Bay House, circa 1870. *Wikimedia Commons.*

his interests in 1867 and invested in the Put-in-Bay Island Wine Company four years later.

Moore's replacement in the Put-in-Bay House ownership was Dr. William Russell Elder, a physician originally from Massachusetts. Upon his taking co-ownership in the company, a large addition was made to the east side of the original building, and the grounds were greatly improved. These renovations are described in the following advertisement:

> *Put-in-Bay House*
> *H.B. West and W.R. Elder, M.D., Proprietors*
> *Steamboats run every morning and evening from Sandusky and every evening from Detroit, Toledo and Cleveland.*
> *New features for 1867.*
> *A large addition has been made to the House, which is divided into private parlors with bedrooms attached, sitting rooms, etc....*
> *A large two-story building has been erected on the premises and near the hotel by Josiah Stacey, who for a long time has been a successful caterer to the Cleveland public, whose name alone is a good guarantee that it is*

*a first class institution, and has devoted the whole to the amusement and
entertainment of guests. The gents' department is furnished with Billiards,
Bowling Alley, Gymnasium, &c. The ladies will find apartments for Ice
Cream, Native Wine, Croquet games, Bowling, &c. The upper part is
divided into suites of Photographic Rooms, fitted up in good style, occupied
by H. Benedict, a first class artist.*

A Good Barber and Hair Dresser in attendance.

Good music for hops, &c.

*Capt. Moore, a former partner, has disposed of his interest to Dr. Elder.
The Doctor is a graduate of the Berkshire Medical College, Massachusetts,
and has had an experience of twenty years. This is a great convenience for
visitors who spend the season, as there is no other resident physician.*

*Fishing Boats, Tackle and Bait will be furnished by Henry Gibbens, to
all that may want.*

We are not troubled with gnats or mosquitoes.

Like his predecessor, Dr. Elder remained only one year. He sold his
interests in the firm and moved west to Terre Haute, Indiana, where he
continued his career as a homeopathic doctor until his passing in 1907.

Henry West's new partner in the Put-in-Bay House was "Colonel" Merit
Sweny. With the addition of a new investor, so too came improvements to
the hotel. During the winter of 1869–70, many new amenities were added.
The most impressive of these was a three-story wing that was added to
the west side of the hotel. It measured 40 feet wide and 166 feet long and
contained 95 double rooms. This brought the total number of rooms to 375
and made the structure over 500 feet in length. Thus, the Put-in-Bay House
became the largest summer hotel west of the Allegheny Mountains. A grand
veranda, measuring 315 feet in length, adorned the front of the hotel.
Reports boasted that the Put-in-Bay House could accommodate between
eight hundred and one thousand guests. The Promenade Hall alone, which
extended through the center of the entire building, was 500 feet in length
and was lit by one hundred gas lights. The dining hall measured 50 feet by
150 feet, and the attached dancing hall measured 50 by 100 feet. Other
amenities included gas-lit bedrooms, running water throughout the hotel, a
steam laundry and livery stables. The grounds were equally beautified with
the addition of two fountains that contained a wide variety of fish.

In 1871, the Put-in-Bay House was sold to the firm of Cooke and
Burgher of Cincinnati, though Henry West and Colonel Sweny stayed on
as managers. Throughout the years of operation, the hotel hosted many

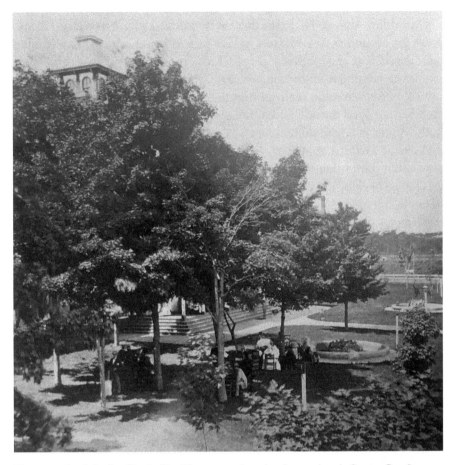

The grounds of the first Put-in-Bay House were luxuriously appointed. *Courtesy Dan Savage and the Lake Erie Islands Historical Society Museum.*

gatherings and small conventions. One such convention, which was held each September from 1872 through 1875, was the Fat Men of the West Convention. The president was chosen each year based on his superior size, with the motto being "May the fattest man win." The heaviest was known to have been over five hundred pounds.

By 1878, the Put-in-Bay House had again changed hands. The new owners were Sol Langdon of Cincinnati and John Gardiner of Norwalk. As was the case before, West and Sweny remained operators of the facility. For the 1878 season, the Put-in-Bay House was repainted and redecorated with new furnishings. These updates were only enjoyed for a few short months, as that season would be the hotel's last.

On Friday, August 30, 1878, there were about 250 guests staying at the hotel. At around 6:00 p.m., just as dinner was being served in the dining hall, guests and staff noticed the smell of smoke. At first it was believed that it was coming from the kitchen. The windows were opened to clear the smoke, but it was soon realized that the kitchen was not the source. Staff members stepped outside and at once saw flames pouring from the cupola in the center of the main building.

As soon as he was alerted, Colonel Sweny ascended the stairs to the cupola but found that the fire was beyond his ability to extinguish, and he was forced back by the intense heat. Sweny got a few men together and tried to tap into the hotel's water system, but the fire hose was too short to reach the cupola. A bucket brigade was formed, but this had little effect on the flames. At first, the fire was relatively slow spreading, which gave the hotel's guests enough time to remove most of their belongings. Unfortunately, this also gave thieves time to enter the building and rob the place. Many of the looters were caught, and much of what was stolen was recovered.

At 6:45 p.m., the cupola and the center of the main roof collapsed. From there, the fire rapidly spread throughout the hotel. By 8:00 p.m., the building was a raging inferno with flames seen from as far away as Sandusky.

Injuries were few and, with the exception of a James Carney of Cincinnati who suffered a broken arm, mostly limited to bumps and bruises. Owing to the lack of an organized fire brigade, a telegram was sent to Sandusky requesting engines to help put out the fire, but by the time a fire engine arrived aboard the steamer *Ferris*, the fire had burned itself out and the Put-in-Bay House was no more.

It having been a particularly windy evening, with a strong wind from the east and cinders being carried on the breeze, the fire destroyed many other structures in the village. Also burned was the first home and shoe store of Chris Dollar, which was soon after rebuilt and is now the Put-in-Bay Surf Shop. Another hotel called the Bing House, which sat on the current site of Town Hall and Hooligans, was a total loss. Also destroyed was the Stacey House, which housed a bowling alley and billiard room.

The cause of the fire was never definitively determined, though it's believed that a few men had gone up into the cupola that afternoon to smoke cigars and a match or cigar butt was left smoldering.

Most of the displaced guests were given accommodations at the nearby Beebe House and Hunker House. Others were put up in the Bachelor's Cottage, where the male hotel employees were housed. Still others were given shelter by island residents.

The next morning, all that remained of the Put-in-Bay House was the foundation. Furniture and other items from the hotel were strewn about the grounds out front. Estimates for the damage were placed between $75,000 and $100,000, though insurance was held at only $40,000.

The owners gave thought to rebuilding but weren't sure if or when that would happen. In fact, eleven more years passed before a second hotel graced the site. Henry B. West moved to Cleveland, where he continued in the hotel industry until his death in 1888.

SECOND PUT-IN-BAY HOUSE

For the next ten years, the site of the Put-in-Bay House remained an empty field, untouched and overgrown with weed-choked tall grass. In February 1888, the Put-in-Bay Hotel Company was established and sought to build a massive hotel on the site of the first Put-in-Bay House, but those plans were foiled. The property had been purchased by the island's most prominent citizen, Valentine Doller.

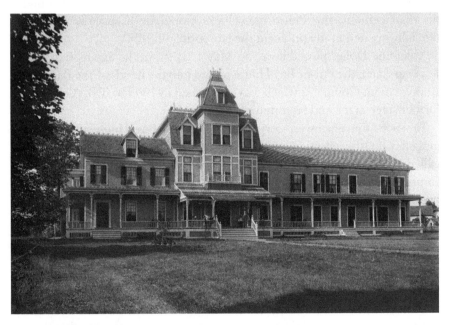

The second Put-in-Bay House, circa 1900. *Library of Congress.*

Valentine Doller, a native of Bammental, Baden, Germany, came to the island with his father, brothers and wife, Catherine, in 1859 and took over operations of the island's steam sawmill. In time, he opened his own general store, as well as the telegraph company, and became Put-in-Bay's mayor.

Construction of the second Put-in-Bay House commenced in 1889, with the hotel being built in two phases. It proved to be a much smaller structure than the previous hotel. Furthermore, it was located much farther back from the road, being five hundred feet from Delaware Avenue. This afforded the property a large front lawn with a fountain and beautiful landscaping. In all, there were fifty-five rooms. The lobby and office were located just inside the main entrance, with most of the guest bedrooms upstairs. The first phase was completed on August 1, 1889.

The spacious dining hall was part of the 1890 annex, as were the employees' quarters, laundry rooms and kitchen, which boasted a combination steel plate range and steam table. In February of that year, J.B. Ward was named proprietor.

James Belcher Ward, who hailed from Ashtabula, had previously operated the Ballast Island Resort. He was described as being a pleasing gentleman and a first-class caterer and hotel manager. There was no doubt that under his management, the Put-in-Bay House would be a success. The hotel officially opened to the public in the late spring of 1890.

Valentine Doller passed away on May 1, 1901, at the age of sixty-six. A few years later, the Put-in-Bay House passed into the hands of the Put-in-Bay Improvement Company, which was established in 1905 by T.B. Alexander, a former stage actor and later mayor of Put-in-Bay.

In 1906, the northwest corner of the Put-in-Bay House property was graced with the addition of a dance hall and general-purpose building called the Colonial. This was done under the direction of the Put-in-Bay Improvement Company. More on that building can be found later in this book in the chapter "Village Sites."

Not long after the property passed into the hands of the Put-in-Bay Improvement Company, the Put-in-Bay House was leased to John M. Kammeron, a German-born saloonkeeper from Cincinnati.

On the night of Tuesday, September 3, 1907, a fire was discovered at about 10:30 p.m. in the basement of the hotel. Guests were forced to hastily evacuate the building, leaving most of their possessions behind. Fortunately, there were no reported injuries. There were, however, concerns that the fire would spread to other nearby buildings, including the newly built Colonial,

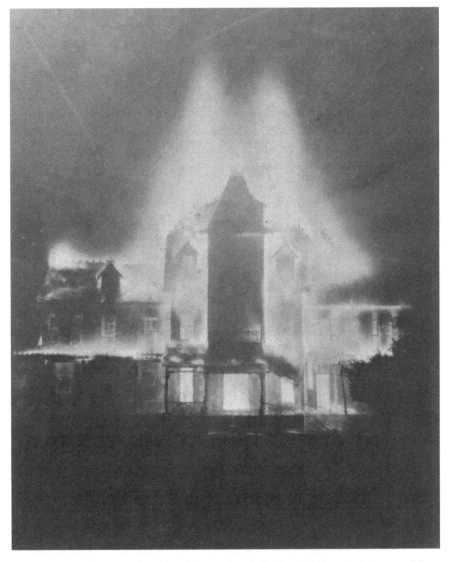

The fire that broke out on the night of September 3, 1907, which destroyed the second Put-in-Bay House. *Courtesy of the Lake Erie Islands Historical Society Museum.*

but by 1:30 a.m., the fire was brought under control and the neighboring structures were spared.

Like its predecessor, the second Put-in-Bay House was a total loss. Damage estimates were put at $15,000, but insurance was only carried at $6,000.

The fire seemed suspicious from the start. Fire Marshal Frank H. Dimon, who was investigating the conflagration, suspected arson. Not long into his

investigation, he had a suspect. That suspect was John M. Kammeron's twenty-four-year-old nephew John Schmidt.

Four years earlier, Schmidt's father had passed away, leaving him and his two younger siblings orphaned. Kammeron, who was named executor of the estate, hired John Schmidt to work as a dishwasher at the hotel in 1905.

After questioning, John Schmidt denied all knowledge of what had caused the fire at the Put-in-Bay House. He did, however, confess to starting a fire in a small town near Cincinnati. Dimon had Schmidt placed in the custody of the Put-in-Bay marshal while he returned to Sandusky to make inquiries regarding the fire Schmidt had just admitted to. A couple of days later, John Schmidt escaped custody. From Put-in-Bay, he hired a man to row him to Middle Bass, where he boarded the steamer *Frank E. Kirby* bound for Detroit.

After successfully eluding police in Detroit, Schmidt made his way south to Toledo. He boarded a train to Hamilton and then walked to Cincinnati. Marshal Dimon received a tip and pursued Schmidt south, where he was assisted by deputy state fire marshals William H. Sweeney and John Ambrose. In their investigation, they questioned Schmidt's acquaintances and learned through one, who had received a letter from Schmidt, that he was working on the farm of William Carroll, six miles west of Hamilton, under the pseudonym Thomas Wilson. John Schmidt was taken into custody on September 27.

Schmidt was returned to Put-in-Bay the following day and was formally charged with arson. He finally admitted to setting the blaze, claiming that it was revenge for having been wronged by his uncle, the hotel's proprietor. He stated that early in the evening of September 3, he went into the basement below the employees' quarters, where he smashed an oil lamp. He then poured the oil about the place, lit it and hastily fled. He hid out nearby and expected the hotel to be ablaze in a short time but was disappointed to find that the fire had burned itself out. He returned to the basement and reignited the oil, this time making certain that the flames would spread. At this, he quickly fled the scene.

Not only did John Schmidt admit to setting the fire, but he also confessed to the killing of J.B. Ward's horse with a pitchfork the previous April. This, he claimed, was done because the horse had kicked him.

Schmidt, who it was reported was of a diminished mental capacity, was ultimately judged to be "insane" and was remanded to the Toledo State Hospital.

THE BEEBE HOUSE

Located on Bayview, between Hartford and Toledo Avenues, stood one of the grandest hotels to grace the Lake Erie Islands. The main structure held a commanding view of the bay, while the extensive grounds boasted multiple buildings for the amusement of guests. Surprisingly, this impressive accommodation had very humble beginnings.

Frederick W. Cooper had settled on South Bass Island by 1863, having previously purchased a strip of land that is now occupied by the Crew's Nest. By 1865, he and his family were living in a one-story grout house composed of two rooms, located just beyond the east end of the grove of trees that the following year became DeRivera Park. Of note, Frederick Cooper was one of three original trustees of the park.

In 1866, Cooper added three more rooms to the small house, each room leading to the next. That year, he started putting up boarders who were seeking accommodations on the island. The only other hotel available was the recently opened Put-in-Bay House.

Over the winter to 1867, the five-room grout house was enlarged. That spring, Cooper took on a partner named Andrew B. Decker and operated the building as a hotel called the Island Home. That fall, it was enlarged yet again and reopened in 1868 as the Perry House. Reports claimed that it was "furnished in a very comfortable manner" and that it was "a well-kept house."

In the spring of 1869, the Perry House was sold to Henry Beebe, who at first retained the name but changed it to the Beebe House the following spring.

Henry Beebe was born in Elyria, Ohio, on July 24, 1822, to parents Artemas and Parmelia Morgan Beebe. He was raised in the first tavern in Elyria, which was built by his father in 1818. The original Beebe House was a brick hotel located on the northwest corner of Elyria's Public Square. Built by Artemas Beebe in 1846, it was Elyria's first four-story building and was the largest hotel between Cleveland and Toledo. On February 14, 1848, Henry was wed to Abby Sexton. The two took up residency in Elyria's Beebe House, where Henry was made landlord of the concern.

Sadly, Abby passed away on April 12, 1863. Henry continued to operate the Elyria house for his father until the spring of 1869, at which time he sought a change. At this, he handed over management of the hotel in Elyria to Edwin Hall and purchased the Perry House at Put-in-Bay from Frederick Cooper and Andrew Decker.

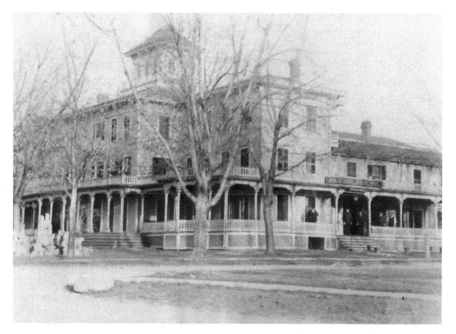

The Beebe House, circa 1900. *Courtesy of the Lake Erie Islands Historical Society Museum.*

After changing the name from the Perry House to the Beebe House, Henry realized that further changes were needed. In 1871, he hired the firm of Gascoyne and Montgomery to remodel the original three-story hotel. He added a new wing to the structure, which brought the total number of rooms to one hundred, giving it a capacity of four hundred guests. Also added were large first-floor verandas that wrapped around two sides of the hotel. The addition also included a billiard room and bar.

The Beebe House was luxuriously illuminated with gas lights and contained a large dining room on the first floor with the dance hall located in the room above. The lobby was finished with tin ceilings and elegant area rugs and had green walls with white trim. All in all, it carried similar amenities to those found at the first Put-in-Bay House on the other side of the park. A layout of the grounds shows that the hotel had a separate building that later housed the billiard hall, bowling alley, ice cream salon and wine room. Another building housed the laundry on the first floor, with staff accommodations on the second. A livery stable and icehouse were also on hand. Set at the northeast corner of the property was the little Beebe Cottage.

Following the fire and destruction of the first Put-in-Bay House, the Beebe House became, by default, the largest hotel on the island, a title it held for the next fourteen years. Two months after taking that title, Henry Beebe was married to Mary L. Stretcher. The Beebe House continued to see many years of successful operation under Henry's management.

In 1900, Henry Beebe retired from active operation of the hotel, and management was taken over by H.W. Crowfeldt. Henry Beebe died on February 15, 1905, at the Madison Hotel in Toledo, where he and his wife resided during the winter months.

Shortly before retiring, Henry and Mary Beebe opened up the little Beebe Cottage on the hotel's property to guests. Mary Beebe continued to operate it through 1911. The year before, she had leased the Beebe House to William Homer Reinhart, state conservation commissioner, who spent the next three years renovating and updating the aging structure. Along the way, he enclosed the first-floor verandas with screens to keep out insects and renamed the establishment the Hotel Commodore.

In 1913, the entire property was purchased by the Schlitz Brewing Company, which took advantage of the large icehouse on the grounds. William Reinhart decided not to renew his lease in 1914, owing to the fact that he had recently made a large investment in wine interests in North Carolina and California. Operations were taken over by Julia Sands of Toledo.

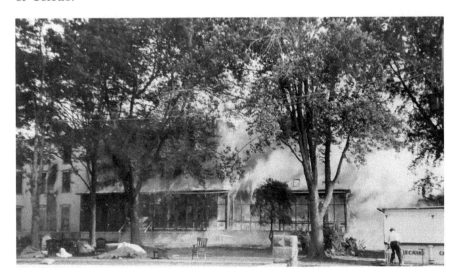

Fire at the Hotel Commodore, formerly the Beebe House, August 23, 1932. *Courtesy Dan Savage.*

On the afternoon of Tuesday, August 23, 1932, guests noticed smoke coming from the third floor of the hotel. The fire department was called at once, but by the time the island's one pumper arrived, the flames had spread beyond control. All that could be done at that point was to keep the fire from spreading to other nearby structures.

By day's end, the once grand hotel was nothing more than a pile of charred embers. Damage estimates were placed at $100,000. No injuries were reported, but the hotel was a total loss. The cause of the fire was attributed to faulty wiring on the third floor.

The Schlitz icehouse remained on site for a few years after the fire but was torn down to make way for a bicycle rental stand and, later, Chick Linkers Restaurant, which today operates as the Boathouse. No traces of the Beebe House complex remain. The front lawn that offered amazing vistas of the bay is now the Peace Garden of Perry's Victory and International Peace Memorial.

THE BAY VIEW HOUSE

Past stories claimed that the Bay View House was built in 1870 by a man named William Gibbons. This appears to be erroneous though, as no such person existed.

John Samuel Gibbens was born on July 1, 1819, in Belchamp St. Paul, Essex, England, to Robert Gibbens and Mary Elizabeth Downs. His father having passed in 1822, John moved some years later to the United States with his widowed mother and settled first in Plattsburgh, New York. It was there that he married Mary Jane Eugenia Seymour, a native of Canada, on March 4, 1837. They started a family and by the late 1840s had moved west to Cleveland, where in 1850 John was working as a carpenter. Around 1862, John Gibbens purchased a sizable tract of land on South Bass Island and settled there with his family the following year.

Henry Samuel Gibbens, John and Mary's eldest child, was married in Cleveland to Melissa Maryfield on November 18, 1862. They became the parents of two children, Minerva Agnes and John Chester. After settling on the island with his family in 1863, Henry first worked as a carpenter but turned his attention to sailing.

In 1870, John and Henry Gibbens built what would later become the Bay View House. It began its life as a two-story frame house that was set

a good distance from the shore and served as the home of Henry, Melissa and their two children.

Just before 1880, Henry and Melissa Gibbens divorced, and Henry moved to San Diego, California. With Henry having left his family, Melissa and her children continued to reside in the home that Henry and his father had built. She was married in 1881 to a man named Stephen Smith and by him had a son named Rivera. Not long after the birth of their son, Stephen Smith passed away.

Mary Gibbens died in 1886, leaving John a widower. He was married the following year to Christina Edwards in Sandusky, but the marriage was short-lived. The two divorced in the summer of 1890. At this, Melissa and her children took up residency with John Gibbens, who since settling on the island in the 1860s had lived in a house next door.

It was then that the house that John and Henry Gibbens built in 1870 first saw use as an island accommodation. It was leased to John J. Day of Put-in-Bay, who opened it as the Bay View House. According to an advertisement that ran in the *Cleveland Plain Dealer* on June 30, 1891, he offered good private board and rates at $1.25 per day, or $7.00 per week.

An undated photo of the Bay View House. *Courtesy Dan Savage.*

John Gibbens died on March 22, 1892, in Florida, where he was wintering. Per his last will and testament, all of his real property was to be sold and the proceeds divided between his heirs. Included in this was his home and the one previously occupied by Henry and Melissa that was in his name. John Day purchased both lots.

John J. Day, who was fondly known on the island as Jack, was a native of Schuylkill County, Pennsylvania. Jack came to the island in 1887 and originally worked as a laborer for architect and builder George Gascoyne. Around the turn of the century, he served as mayor of Put-in-Bay.

Not long after taking possession of the former Gibbens house, Jack Day had it moved closer to the bay from its original location. He then hired John Feick to add a third floor to the structure. With these additions, the hotel could accommodate more than 150 guests. To add to the amenities, he had cottages set up behind the main building.

Jack Day was consistent in maintaining up-to-date accommodations. His Bay View House offered excellent meals and good service. Furthermore, boats at a nearby dock were available for the use of visitors. By 1911, the hotel was updated again and was being billed as a quiet, shady spot, away from the noise, dust and confusion. Pure fresh milk, home cooking and fresh vegetable, chicken and fish dinners were a specialty.

In 1923, Jack Day sold the lot previously occupied by John Gibbens to the Put-in-Bay Yacht Club for the construction of its clubhouse. During that time, Jack also served as proprietor of the Bon Air Hotel, which today operates as the Country House.

Throughout much of the first half of the twentieth century, the Bay View hosted many events for the Inter-Lake Yachting Association's annual regatta, including the garden and bridge parties, and accommodated countless participants and their families. The neighboring Put-in-Bay Yacht Club is affiliated with that association.

In 1949, the Bay View House was sold to William F. Waldeisen and a Cleveland attorney named Ralph Bailey. H.D. Gantzos was named manager of the hotel and dining room. As the place was a popular stay for participants of the annual I-LYA regatta, it was advised that they verify their standing reservations with the new management.

By 1954, the Bay View House was operating under the name of the Rendezvous Hotel and continued under that moniker through the late '60s. It was sold again and became the Bayview Inn and Boatel in 1970. This occurred when it was acquired by Ed and Betty Trebilcock of Westlake, who also operated the Perryvu Marina on the bay in front of the inn. The hotel and docks were managed by their daughter Bunny.

The Bayview Inn was purchased a few years later by the owners of the Crew's Nest. Having fallen into disrepair, it was torn down in the fall of 1976. It's now an empty lot between the Put-in-Bay Yacht Club and the Dodge House.

THE HERBSTER HOUSE

At the corner of Catawba Avenue and Erie Street, across from the Reel Bar, sits an outdoor bar that's been built around an old fire engine. But 150 years ago, this corner looked very different. It was there that the Herbster House operated for a number of years.

Herman Conradus Alexander Herbster was born on September 3, 1843, in Kirchhofen, Baden, Germany. He came to the United States in 1868 and three years later found himself at Put-in-Bay. Herman originally operated a concession and refreshment stand on the steamer *B.F. Ferris*, which traveled between Sandusky and Put-in-Bay. He then opened a bakery on the corner of the lot behind the first Put-in-Bay House. In 1878, the bakery building was largely remodeled by Henry Gibbens and became a restaurant, saloon, bakery and rooming house. This building miraculously survived the fire that claimed the Put-in-Bay House and Bing House that summer. Herman Herbster was married in 1873 to Maria Leberer. They raised four children together.

While the Herbster House took in roomers at fifty cents per night, the main income was from the restaurant, saloon and bakery. A sign mounted out front advertised beer, wine and an island bakery. Directly over the front porch was another sign that read "Restaurant." Meals were priced at thirty-five cents. A sign painted in the windows advertised fresh bread, cakes and pies.

In the spring of 1888, Herman Herbster took a trip to Dayton to visit his son, who was away at school there. At the close of his trip, he was returning home by train on the Cincinnati, Sandusky & Cleveland Railroad, and on the evening of May 18, he took ill. That night, shortly before midnight, he felt very faint and needed to get some fresh air. He stepped out onto the platform between two of the cars and lost his footing. Falling beneath the wheels of the train, he was killed instantly. His remains were returned to Put-in-Bay for burial at Crown Hill Cemetery. Herman Herbster was forty-four.

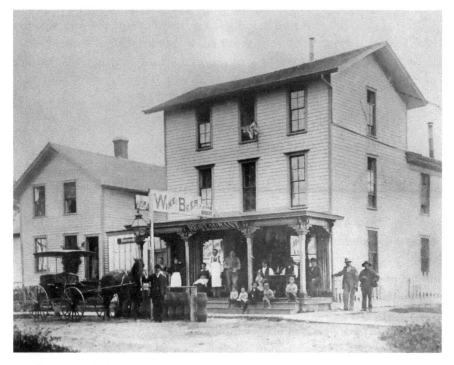

The Herbster House, Restaurant and Saloon, which later became the Perry Hotel, circa 1885. *Courtesy Dan Savage.*

The Herbster family continued to operate the concern, but ultimately, the children decided to follow their own callings. The youngest, Otto, went on to become the most well-known photographer on the island, having documented the construction of the Perry Memorial.

In 1905, the Herbster property was purchased by Alvin Merkley. At this, the Herbster House was turned ninety degrees, moved back from the road and built onto. The name was changed to the Perry Hotel. With a drop in tourism and the Perry Hotel falling into disrepair, the building was demolished in 1937.

THE CASTLE INN

Not far from South Bass Island State Park, on Niagara Avenue, sat one of the more unique buildings to grace the island. This was the famous Castle Inn, which was built a century and a half ago.

Andrew Schiele Sr. was born on December 31, 1819, in Wurttemberg, Germany, where he received his education and began a career as a baker and blacksmith. In 1850, he relocated to the United States and settled in Toledo, where he operated a restaurant. There, he was married to Justina Kirnberger on October 7, 1851. On June 20, 1865, Andrew Schiele moved to Put-in-Bay with his wife and their four sons, Louis, Robert, Frank and two-year-old Andrew. At first, Andrew Schiele Sr. opened a refreshment stand in the village, where he also briefly operated a bar and hotel.

Most commonly referred to as Schiele's Castle, this unique wooden structure was built in 1871 and served as a combination home and winery. After following business pursuits in the village, Schiele turned his attention to grape growing and wine production. It's said that the design of his home was inspired by the German castles of his childhood.

Andrew Schiele spent less than a decade engaged in the winemaking trade. He died on April 29, 1880. Upon his death, the family winery, as well as occupation of Schiele's Castle, was taken over by his son Andrew Schiele Jr.

The Castle almost met its fiery fate on the morning of August 1, 1916. That year, the island was suffering from the effects of a severe drought. A

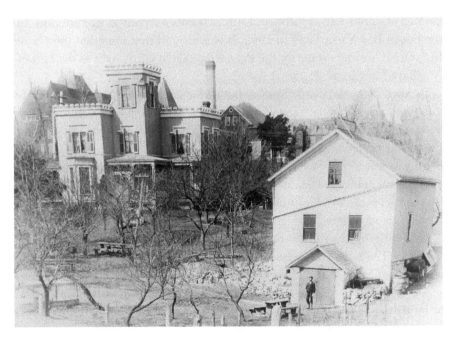

Andrew Schiele's residence and wine cellar, circa 1908. The massive Hotel Victory dominates the skyline to the west. *Courtesy of the Lake Erie Islands Historical Society Museum.*

fire erupted and spread quickly through the dry grass. By 10:30 a.m., eight acres of land were burning. It was only through the efforts of Mayor T.B. Alexander and others that the place was saved. With no fire hydrants in the area, these volunteers used fire extinguishers to snuff out the blaze.

Schiele's Winery continued in operation until the start of Prohibition. Andrew Schiele Jr. died on March 24, 1922. Following his passing, the Castle remained occupied by his wife and daughter.

With the repeal of Prohibition, Schiele's Castle was sold and started doing business as Roy's Castle Inn, which had seating for three hundred guests. The new owner was lifelong island resident Roy Webster. He also resumed production of wine on site and operated Webster's Put-in-Bay Wine Company out of the two buildings located behind the Castle Inn.

A 1952 advertisement celebrated Roy's Castle Inn on "Historical, Hysterical Put-in-Bay" as serving steak, chicken and spaghetti dinners, with a special on charcoal barbecue ribs available on Wednesday and Saturday nights in the island's one and only old-time rathskeller. Every Saturday night, music was provided by Batcha's Polka Aces. Seafood was later added to the menu.

Roy Webster passed away in 1958, and the Castle Inn was soon sold to another islander named Robert Lunt, who also served as commodore of the Put-in-Bay Yacht Club in 1965. It was around that time that the Castle Inn started hosting events for the Put-in-Bay Yacht Club, such as the Ladies' Auxiliary Luncheon.

In April 1966, the Castle Inn was put up for sale, stating that the restaurant and nightclub located on the "fun Island" brought high net profits and had living quarters in the newly decorated building. With the season just starting, the owner was asking for a $20,000 down payment, though a total asking price was not listed. Sales ads ran for the next few years, and in 1970, an advertisement boasted beautiful fixtures, a good building, living quarters and thirteen acres of land for future development. During the winter months, the Castle Inn accommodated ice fishermen.

By the 1970s, the full dinners were replaced with sandwiches. During the winter of 1980, the Castle Inn was the only eatery open at night. It also had a new Party Store that offered beer and wine for carryout.

On January 20, 1982, a fire broke out in the tower at the Castle Inn around 4:30 p.m. A number of ice fishermen were staying there that week, but most were out on the ice at the time. The volunteer fire department responded quickly, but there were still no fire hydrants in the immediate area. A tank truck with a one-thousand-gallon capacity was brought in, but

The Castle Inn became a popular stop for island tourists. *Courtesy Dan Savage and the Lake Erie Islands Historical Society Museum.*

that was quickly depleted. Strong winds fanned the flames, and the fire was soon beyond extinguishing. By the end of the day, the Castle Inn had burned to the foundation. It was suspected that the fire was caused by a space heater that had overloaded an electrical outlet.

Though the Castle Inn was no more, the foundation and cellar were saved. The former rathskeller is now a residential space and is primarily rented to seasonal island employees.

THE BASHORE HOTEL

Situated along the east side of Toledo Avenue was what, for a brief time, was the island's largest hotel. Like most early accommodations, it also had modest beginnings. In the early 1890s, Julius Wurtz Sr. built a small rooming house that could sleep up to twelve guests. His time of welcoming vacationers was brief. Julius Wurtz was horrifically killed on January

24, 1895, after falling into an ice elevator at the island's Forest City Ice Company, where he was employed.

The former Wurtz Rooming House on Toledo was sold to Benjamin L. Smith, a plumber from Attica, Seneca County, around 1910. It's said that Smith originally came to the island on a horse-purchasing trip but stayed and worked for Valentine Doller. He was married to an island girl named Lizzie Miller in 1900. Smith reopened the rooming house in 1911 as the Smith Cottage.

In November 1912, Smith built an addition that brought the capacity up to 40 guests. Another addition in 1913 brought the total number of rooms to just over fifty, making room to accommodate 150 guests. At the time, meals were served at a cost of twenty-five cents, and room and board were available for seven dollars per week.

Around 1920, Benjamin Smith built a small residence just to the north of the Smith Cottage. That same year, his eighteen-year-old son, Walter, was assisting him in hotel operations. When his son Edwin married in 1922, the small house was given to him and his wife, Lenore, as a gift.

Through the late 1920s, the hotel continued to operate under the moniker of the Smith's Cottage. By the early 1930s, the name had been changed to the Smith Hotel, and it was operating under the direction of Walter. By the mid-1930s, Walter Smith had fallen into financial difficulty and lost the hotel to the bank. In 1937, Walter took over the Bon Air Hotel on Delaware Avenue, formerly the Gill House and Hotel Oelschlager, and reopened it as the Smith Hotel. The Delaware Avenue building continued under that name through the late 1960s. Today, it operates as the Country House.

Following the bank's foreclosure of the former Smith Hotel on Toledo, it was rented in 1944 to a local commercial fisherman named Ralph Morgan, who changed the name to the Morgan Hotel. It's been said that in October 1944, the hotel was sold to Mrs. India Boelcher, a former cook from the Bay View House, who reopened it in the spring of 1945 as the Bashore Hotel. No biographical information can be located on India Boelcher. It's known that the hotel was being operated by a woman named Edna Anderson by 1958.

On May 27, 1953, the kitchen, dining room, laundry and operator's living quarters burned. At around 12:45 a.m., the fire was discovered by high school student Mac McCann, who was returning home. The fire department had the blaze under control by 3:30 a.m., but the rooms mentioned were a total loss. Some of the guest rooms received significant water damage, but most survived unscathed. The fire was caused by defective wiring in the kitchen.

The Bashore Hotel, formerly the Smith Hotel, on Toledo Avenue. *Courtesy Andrea Lee of AB Lodging.*

Following the fire, the wing where the fire broke out was shortened, which brought the number of guest rooms down to forty. Estimates of the fire were placed at $20,000. Also destroyed in the fire was a garage that sat to the south of the building and was owned by Harold Hauck Air Tours, Inc. Margaret C. Kime, who was the manager of the hotel at the time of the fire, was away when the fire broke out.

The hotel was placed up for sale in 1958 and presumably sold. It was ultimately closed and razed ten years later. The small house that Benjamin Smith built and deeded to his son Edwin still stands just to the north of the original hotel site. Today, it exists as AB Carts and Lodging at 222 Toledo Avenue.

THE HOTEL VICTORY

When anyone who frequents Put-in-Bay thinks of historic island hotels that no longer exist, the first that usually comes to mind is the world-famous Hotel Victory. Photos of this architectural masterpiece—and especially of the fire that consumed it—may be found all over the island. The Lake Erie

Islands Historical Society Museum has a particularly detailed exhibit on the Victory that's more than worth checking out. Were this hotel still standing today, it undoubtedly would be known the world over. Sadly, it now only exists in photos, artifacts and legend.

To begin with, the Victory was the brainchild of James K. Tillotson, a resort developer from Toledo. He hatched a plan to build a hotel on a scale never before seen on the Great Lakes. These plans commenced in December 1887 when Tillotson held a meeting with the residents of South Bass Island at the office of Put-in-Bay mayor Valentine Doller. The plan was received with enthusiasm, and a committee was formed to solicit investors. In February 1888, the Put-in-Bay Hotel Company was established. The original intention was to build a new resort on the site of the first Put-in-Bay House, which had burned down ten years earlier. For a time, an alternate site was looked at, that being on East Point, just beyond the current site of Perry's Victory and International Peace Memorial. The investors fought this and opted for the original plan, but this had come too late, as Valentine Doller had already purchased the site with the intention of building his own establishment. A new location was sought.

The goal was to have this new resort opened by June 1, 1889. Though the Put-in-Bay Hotel Company had accumulated $325,000 in capital, building a hotel on the scale they were looking at in that timeframe was unrealistic. Finally, a new site was selected and plans commenced.

The new affair was designed by Toledo architect Edward Oscar Fallis and built by the Feick Construction Company. Building estimates for the project ran from $300,000 to just over $500,000. The cornerstone was set on Tuesday, September 10, 1889, the seventy-sixth anniversary of Perry's Victory at the Battle of Lake Erie, for which the hotel was named. Nearly four hundred people were working on the hotel at any given time throughout its construction.

Though the hotel was still a few years from completion, the Victory started welcoming guests on June 29, 1892. The formal grand opening was held two weeks later on July 12 with ceremonies, fireworks and a banquet.

To say that the Hotel Victory was an imposing structure would be an understatement. It was built in the popular Queen Anne style, featuring many towers, dormers, gables, turrets and spires. There were no fewer than 2,500 windows and six thousand electric lights. It also exhibited multiple wraparound porches and verandas. The palatial island retreat boasted four floors of guest accommodations. The main hotel structure stood at five stories, with some of the towers reaching as high as eight stories into the air.

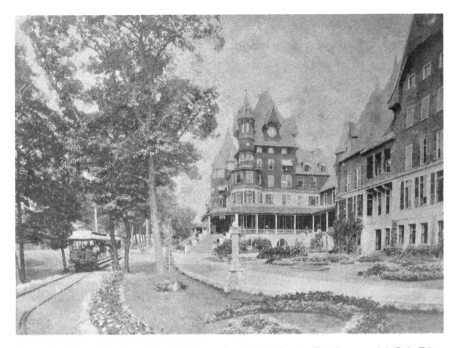

A popular view of the famed Hotel Victory, circa 1900. *Courtesy Dan Savage and the Lake Erie Islands Historical Society Museum.*

The Victory was famously billed as the world's largest summer hotel. The main part of the building housed the guest rooms and measured three hundred feet by three hundred feet alone. Another three-hundred-foot-long section extended to the southeast and contained most of the common areas. It offered 625 guest rooms, 80 of which were suites with their own private baths. Without a doubt, it was the largest resort hotel as far as capacity was concerned and could accommodate up to 1,500 guests. The equally famous Grand Hotel on Mackinac Island could accommodate 1,000.

The various public spaces offered to guests were impressive in their own right. There were two dining halls that could seat a total of 1,200 guests at once. It also had an electric-lit ballroom and assembly room. The auditorium had seating for 700, while the lobby could hold up to 1,000 visitors. Other amenities included a bellboy service on each floor, three elevators, a billiard room with ten tables and multiple writing rooms where guests could fill out postcards or other letters to send home. The hotel had its own post office, newsstand, telegraph office and the island's only long-distance telephone service.

Other services offered by the Victory were laundry, a dentist and doctor's office, tailoring, barber services and hairdressers. All in all, the Victory employed a staff of around three hundred, most of whom were housed on the grounds.

The Victory property covered a total of one hundred acres, twenty-one of which were reserved for the hotel and its immediate grounds. The rest were set aside as cottage lots for the homes that were planned to surround the massive resort.

The scenic Victory Park covered the grounds between the hotel and the lake. It contained beautiful landscaping, a wooded grove, a stony ravine, footpaths and a rustic bridge.

The inner courtyard of the hotel, which was surrounded by the guest accommodations, measured forty thousand square feet in size and featured afternoon band concerts provided by the hotel's orchestra, which regularly performed Robert Buechel's "Hotel Victory March." The orchestra also performed in the main lobby each morning and evening and in the ballroom on weekend nights.

The property was serviced by an electric railroad that brought guests from the downtown docks to the resort. This is discussed further in the next chapter.

One of the most memorable features the hotel offered was the covered outdoor swimming pool, called the Natatorium. It was one of the first co-ed swimming pools in the United States. Back then, swimming with members of the opposite gender was considered risqué.

Ultimately, the idea was that the sale of the cottage lots around the hotel would cover the cost of construction. However, only a few of those lots were sold, and those not nearly fast enough. Two months after opening, the hotel went into receivership. Tillotson leased the hotel the following season but abruptly closed its doors on August 10, 1893.

After being closed for two years, the Victory was sold in 1895 at auction to architect Edward Fallis, who was one of only two bidders. Upon taking possession, the sections of the hotel that remained incomplete at the grand opening were finally finished. The following February, Fallis sold the resort to John Darst and Lysander K. Parks, who reopened it in the spring of 1896.

In May 1899, the Hotel Victory property was seized under a writ of attachment in favor of brothers Charles and William Ryan of the Arbuckle-Ryan Company of Toledo, who held a $41,000 claim against the hotel. At this, Parks and Darst were out, and Thomas Willis McCreary was named manager of the Victory.

Throughout the years that it was open, the Hotel Victory was a popular destination for many late nineteenth- and early twentieth-century celebrities, including presidents, senators and generals. Even Abraham Lincoln's son, Robert, was an occasional guest. The Victory hosted numerous conferences and conventions and was the original headquarters for the annual I-LYA regatta. And throughout those halcyon days, T.W. McCreary was grand master and host of it all.

On August 5, 1907, a twenty-two-foot-tall copper and bronze statue of the winged Goddess of Victory, holding a staff and laurel wreath, was unveiled on the grounds of the hotel in Victory Park. Sculpted by Alfons Pelzer, the cost was $2,000. One of the guests in attendance at the unveiling was Oliver Hazard Perry III, grandson of the famed commodore whose triumph on Lake Erie this statue was dedicated to. McCreary saw the dedication of this statue as his life's crowning achievement, even overshadowing his part in the placement of a memorial to the victims of the Ashtabula Bridge Disaster in Ashtabula's Chestnut Grove Cemetery. McCreary personally designed the sculpture, raised every dollar of its cost and supervised each phase of its construction.

Shortly after the unveiling, Thomas McCreary collapsed from a stomach complaint that had been bothering him greatly for some time. Seeking aid, he visited Kellogg's sanitarium at Battle Creek, Michigan. Finding no assistance there, he checked into a hospital at Detroit, where he was diagnosed with late-stage stomach cancer. At this, he returned to his old home in Erie, Pennsylvania, where he expired at St. Vincent's Hospital on the evening of October 16, 1907.

The next manager was Colonel Rodney J. Diegle, but his term was short-lived. The Victory saw a drop in visitation, and the Ryan brothers closed the resort in 1909.

For the next number of years, the Hotel Victory sat shuttered and alone, a ghost on the landscape above the windswept, craggy cliffs of Lake Erie. Then, in January 1916, it was announced that the dilapidated resort had been purchased by Robert Hosbury of Columbus. It was believed that Hosbury, an agent of the state agricultural commission, was representing other interests. Nothing came of the matter. In 1917, the resort was purchased by Walter Emmett Flanders Sr., president of the Flanders Automobile Company of Detroit. Flanders commenced a restoration of the hotel and grounds, but it never opened.

Finally, in the spring of 1919, the Hotel Victory was purchased by Harry Joseph Stoops, the head of a Chicago syndicate. Originally, the concern was

managed by J.A. Stokes, but after only a couple of months on the job, Stokes submitted his resignation. Management was then taken over by Stoops's nephew Benjamin R. Mowery.

It was looking to be a successful season for the reinvigorated resort. The conferences and conventions were returning. No one knew that the grand accommodation was about to breathe its last.

On the evening of Thursday, August 14, 1919, a fire broke out in an upper cupola at the northwest corner of the building. The blaze was discovered at 7:45 p.m. by a neighbor who called the hotel's front desk to inform them of what was transpiring. By the time the staff reached the cupola in question, the fire was beyond containment. There was nothing to be done but evacuate the hotel and leave the flames to do their work. Guests and staff raced to remove personal belongings and furniture from the hotel and were seen carrying items out onto the front lawn. Many of these items were later hauled off by looters.

Within minutes, the Hotel Victory was a raging inferno. The flames danced over one hundred feet into the night sky and were so intense that they could be seen from as far away as the entrance of the Detroit River. Ashes were carried on the westerly wind as far as Kelleys Island, some six miles away. One by one, each section of the grand hotel collapsed with a sigh and a crash, surrendering itself to its incendiary fate.

No injuries were reported, and all escaped safely, as only a few guests were staying in the hotel at the time of the blaze.

Deputy state fire marshal Alvin C. Ewing of Findlay, who investigated the fire, ruled that the cause was faulty wiring. By dawn, the hotel fire had burned itself out, and only the foundations remained. Harry Stoops, who had left the island a week earlier, returned a couple of days later to survey the ruins.

Damages were initially estimated at around $300,000, but final estimates were placed closer to $1 million. Rumors that the hotel was not insured are completely false. The hotel carried insurance at $126,000, a significant amount, but not enough to cover the cost of rebuilding.

Not long after the fire, the foundations were bulldozed and the site was allowed to be reclaimed by nature. In 1938, the State of Ohio took possession of the grounds, and some years later, it was developed into South Bass Island State Park. A campground now graces the site.

Sadly, Thomas McCreary's celebrated winged statue of Victory was collected for a scrap drive during World War II and was melted down for the war effort, proving that some of life's crowning achievements don't stand the

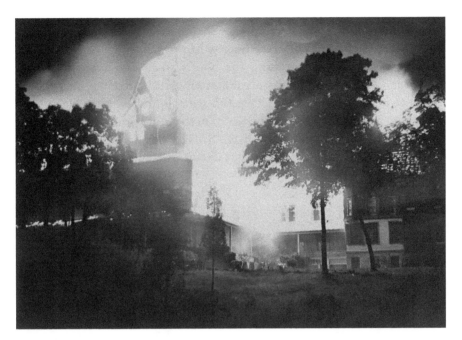

Fire raged through the Hotel Victory on the night of August 14, 1919. *Courtesy of the Lake Erie Islands Historical Society Museum.*

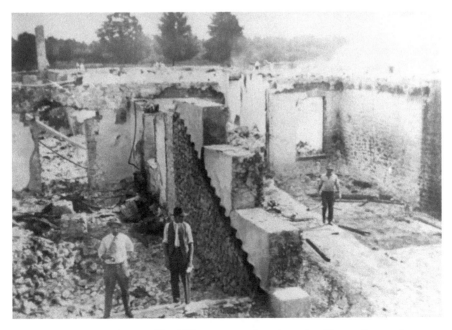

By the following morning, the Hotel Victory was reduced to ruins. Photo taken on August 15, 1919. *Courtesy of the Lake Erie Islands Historical Society Museum.*

test of time. Still, a miniature version of that statue can be found on display at the Lake Erie Islands Historical Society Museum.

The ruins of the Natatorium, the hotel's co-ed swimming pool, still remain and are easily found in the campground. Also present is the pedestal that once held the statue of Victory. Occasionally, relics and artifacts such as flatware and doorknobs are uncovered in the campground area of South Bass Island State Park, where this magnificent hotel once stood. Reminders of the past are everywhere. Sometimes we just need to take a closer look.

Chapter 3

TRANSPORTATION

GETTING THERE

Back in the heyday of early island tourism, an excursion aboard a Lake Erie steamer took upward of two to three hours to reach Put-in-Bay. Ballrooms, salons and dining halls graced the most elegant steamers. After all, getting there was half the fun. Once on the island, an adventure to the caves might be considered, and what better way to get there than by rail? In many cases, the mobs of tourists visited the island for only a few hours before returning to the docks and making the fun-filled voyage home. Later years saw the arrival of air travel. Even that had its adventures.

STEAMER *PUT-IN-BAY*

By far, the queen of the steamships to ply the waters of Lake Erie was the steamer *Put-in-Bay*. Built for the Ashley and Dustin Steamer Line of Detroit, the keel was laid in 1910 by the American Shipbuilding Company near Ecorse, Michigan. It was designed by marine architect Frank E. Kirby, with the assistance of brothers Edward and Oliver Dustin, agents for the firm that owned it.

The hull of the *Put-in-Bay* was of steel construction. It measured 240 feet in length, with a 58-foot beam (width) and a draft of 13 feet. The total weight was 1,182 gross tons. Dimensions given in 1953 placed the vessel as being slightly smaller, with a 226-foot length and a 46-foot beam. It was a single-screw propeller-driven vessel and was powered by a three-thousand-horsepower, four-cylinder, triple expansion engine and four boilers. The *Put-in-Bay*'s top speed was just over twenty miles per hour, or eighteen knots. It could carry upward of 2,800 passengers and required a crew of 110.

The design called for four passenger promenade decks and featured a seven-thousand-square-foot dance hall with a hardwood floor, where an orchestra performed popular songs like the "Put-in-Bay Waltz" and "The Girl of Put-in-Bay." The ship also offered private parlors, cabins, lounges and glass-enclosed lunchrooms and dining halls. It was luxuriously appointed with wicker deck chairs and gilded chandeliers and sconces. The final cost of building this masterpiece was upward of $250,000.

The *Put-in-Bay* was launched on March 25, 1911. Its maiden voyage was captained by North Bass Island native Arthur J. Fox, who remained captain until his death in 1923.

The steamer arrived at Put-in-Bay on its maiden voyage on June 17, 1911, and was welcomed at the dock by a huge crowd, where cannons were

The steamer *Put-in-Bay*, circa 1912. *Library of Congress.*

The grand dance hall aboard the steamer *Put-in-Bay*. *Courtesy Dan Savage.*

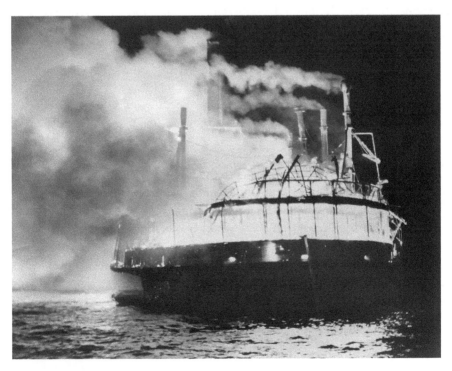

The *Put-in-Bay* was taken to Lake St. Clair and intentionally set on fire on October 3, 1953. *Courtesy Dan Savage.*

ceremoniously fired. The vessel continued on to Cedar Point and Sandusky before making the return trip to the island and home to Detroit. This became its regular route for thirty-eight consecutive seasons.

New federal regulations and declining passenger traffic to Put-in-Bay marked the end of steamer service to the Lake Erie Islands. The *Put-in-Bay*'s final island run was from South Bass Island to Detroit on Labor Day 1948. It departed the dock that evening to a band playing "Auld Lang Syne."

The *Put-in-Bay* continued operations on the Detroit River and Lake St. Clair during the 1950 and 1951 seasons. In early 1953, a number of Put-in-Bay business owners went to Detroit to purchase the vessel but were unsuccessful in securing the necessary funds. It was auctioned by the United States District Court on May 6, 1953, to satisfy tax claims. The purchaser, David Lowe, bought the *Put-in-Bay* for the scrap value. Soon after, it was prepped for dismantlement and was cleared of its rugs, fittings and furniture. Finally, the engine was removed.

With its banners flying at half-staff, the *Put-in-Bay*'s barren hull was towed out onto Lake St. Clair by tugs, where it was set ablaze on the evening of October 3, 1953. Thousands gathered on shore and in nearby boats to witness the spectacle. The following day, the burned-out hull was towed back to River Rouge at Detroit and cut up for scrap.

STEAMER *CHAMPION*

One of the oldest and best-known tugs in its time on the Great Lakes was the steam tug *Champion*. A sister ship to the tug *Vulcan*, it was a familiar sight to the islands throughout the late nineteenth century. While not a passenger vessel, the *Champion* assisted in bringing in many of the great sailing ships that frequented the harbor of Put-in-Bay. It was there that the ship would meet its fate.

The *Champion* was built as hull number 5 by Campbell & Owen Ship Builders of Detroit in 1868 and was constructed for the John Edwards Company of that same town. It was a single-screw, steam-driven tug with a wooden hull and was equipped with an eight-hundred-horsepower, two-cylinder, two-boiler engine. The *Champion* had a length of 134 feet, a beam of 21 feet and an 11-foot draft. Its overall weight was 263 gross tons.

Unlucky from the start, the cabin and wheelhouse of the *Champion* were destroyed on September 27, 1868, while towing its first client, the bark *Alice*,

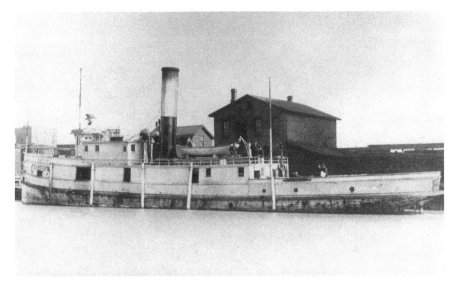

The steamer tug *Champion. Courtesy C. Patrick Labadie Collection, Alpena County George N. Fletcher Public Library, Alpena, Michigan.*

on the Detroit River. Four years later, it suffered heavy damage from a fire at Detroit. Other incidents through the late 1870s and early 1880s necessitated further repairs.

By 1903, the *Champion* was owned by Harris Baker and the Baker Wrecking Company of Detroit. That summer, Captain Elliott Dodge located a vessel that had gone down near Put-in-Bay thirty-six years earlier with 250 tons of pig iron aboard. The *Champion* was brought in to send a diver down to the wreck to ascertain whether any of the cargo remained. Operations wouldn't extend beyond the *Champion*'s arrival.

On the morning of September 15, 1903, the *Champion* burned to the waterline just off Gibraltar Island. The *Champion* was to investigate the wreck that afternoon. At the time of the fire, three men were aboard: the mate, second engineer and the cook. Captain Baker was ashore at the time.

The fire broke out at 8:00 a.m., and by 9:00, the entire vessel was engulfed in flames. With the only lifeboat burning, the men on board survived by climbing over the side and holding onto the anchor chain until they were picked up by other boats.

The small steamboat *Ian* got a line on the *Champion* and attempted to tow it to the small beach at Gibraltar Island, but the flames hampered these efforts, and the *Champion* went aground on a reef, sinking in ten feet of water. At the peak of the blaze, the smokestack glowed red hot, then white, before

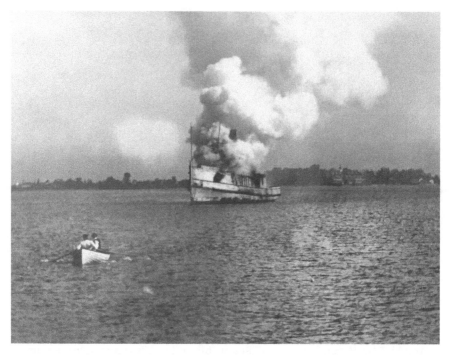

The steamer tug *Champion* on fire just east of Gibraltar Island on September 15, 1903. The dancing pavilion for Wehrle's Golden Eagle Wine Cellar, later the site of Lonz Winery, can be seen in the distance to the right. *Courtesy Dan Savage.*

it melted off and fell into the lake with a sizzling scream that sent billows of white steam into the air.

The cause of the fire was unknown, but it was believed to have started in the oil room. It was immediately realized that the *Champion* was a total loss. Damages were estimated around $20,000, while the vessel itself was only insured for $5,000.

The *Champion* remained on that reef in Put-in-Bay for another year before anything was done with it. Baker returned the following October to size up the matter. A few days later, he brought in the small steam-barge *Snook* and had the machinery stripped off. Two weeks later, the wreckage of the *Champion* was raised and hauled by the *Snook* to Detroit, where it was scrapped.

STEAMER *FRANK E. KIRBY*

Another vessel that was owned by Ashley and Dustin was the *Frank E. Kirby*. Often referred to as the "Flyer of the Lakes," it was built by the Detroit Dry Dock Company at the Wyandotte Boat Works in Wyandotte, Michigan, and was named for its designer. The *Kirby* was launched as hull number 101 on February 12, 1890, and like the *Put-in-Bay* that joined the fleet twenty-one years later, it primarily sailed for the islands, Cedar Point and Sandusky from Detroit.

The *Kirby* was a steel-hulled side-wheel steamer. Its propulsion components were recycled from two other vessels. The boilers came from the steam tug *Monitor*, while the engine was from the recently dismantled *Alaska*. The length of the *Kirby* was 195 feet. It had a 30-foot beam, a draft of 10 feet and weighed 532 gross tons.

It was said at its launching that the *Kirby* was "as sharp as a wedge." It was noted for its speed, which reports claimed could top nineteen miles per hour. A fast vessel for its time, it was also noted for its decoratively ornate cabins.

The *Frank E. Kirby* began service on June 19, 1890. Captain Arthur Fox commanded it before taking on the captain's position aboard the *Put-in-Bay*. Interestingly, Captain Fox kept homing pigeons aboard as a safety measure, should there be cause to send word of alarm.

Not only did the *Kirby* serve as a passenger steamer, but when the need arose, it also aided in marine rescue. On June 2, 1904, the steamer *State of New York* went aground in heavy fog at Sweeney's Point on the west shore of South Bass Island. It took the *Frank E. Kirby* and the steamer *Arrow* to pull it off. The *Kirby* also carried the U.S. mail and, during the harvest season, brought fruit from the islands to the markets in Detroit.

Due to new strict marine regulations, the *Kirby* ceased regular service to the islands in 1919.

In 1926, the name of the *Frank E. Kirby* was changed to the *Silver Spray*, and it took on the route between Erie, Pennsylvania, and Port Dover, Ontario. The following year, its name was changed to the *Dover*.

The *Dover* was severely damaged in a fire at the dock in Ecorse, Michigan, on the night of February 20, 1929. Also burned were the *Erie*, the tug *Annie Moiles* and a ferry called the *Sappho*. Total damages were estimated at close to $250,000. It was believed that the fire was caused by a carelessly flicked cigarette butt from a man standing aboard the *Dover*.

On June 23, 1932, the *Dover* was burned beyond repair at the same dock in Ecorse where it had been damaged three years earlier. Three other vessels

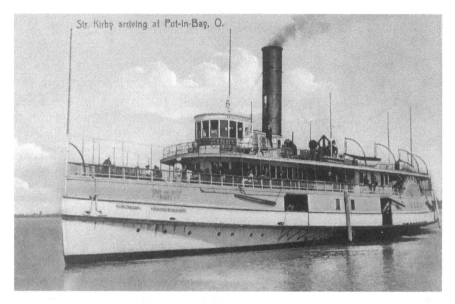

An undated postcard of the steamer *Frank E. Kirby* arriving at Put-in-Bay. *Courtesy Dan Savage and the Lake Erie Islands Historical Society Museum.*

were also destroyed. The *Keystone*, formerly the *City of Cleveland* and later the *City of St. Ignace*, was another passenger steamer. The other two vessels, the *Enterprise* and another small packet vessel, were Great Lakes freighters. The cause of the fire was ruled arson.

For the next seven years, the ruined hull of the former *Frank E. Kirby* lay in waste at the dock in Ecorse where it burned and sank. In 1939, the hull was raised and scrapped.

STEAMER *JAY COOKE*

One of the earlier steamers to ply the waters of Lake Erie was the steamer *Jay Cooke*. This vessel was named for the Philadelphia banker and financier of the Union Army who built his summer home on Gibraltar Island.

The steamer *Jay Cooke* was a two-decked, wooden-hulled, side-wheel steamer that was launched on April 8, 1868, by the J.P. Clark Company in Detroit, Michigan. Weighing 414 gross tons, the *Cooke* was 162 feet long, 25 feet wide and had a 9-foot draft. Its first captain was John Edwards, followed by L.B. Goldsmith.

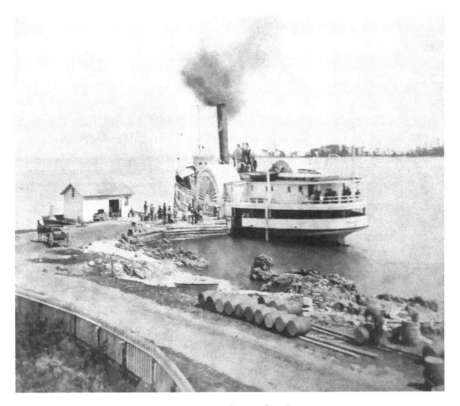

The steamer *Jay Cooke* at Put-in-Bay in 1869. *Courtesy Dan Savage.*

The *Jay Cooke* was renowned for its speed and, because of this, frequently made headlines. On the afternoon of Thursday, May 18, 1882, the *Cooke* was engaged in a race against the steamer *American Eagle*. While crossing the *Cooke*'s bow, the *Eagle*'s boiler drum exploded, blowing the smokestack overboard and setting fire to that vessel. It was reported that the fireman, Frank Bittel, and deckhands Frank Walters and Lorenzo Neilson were scalded to death. Others received severe injuries but survived.

The steamer *Jay Cooke* was sold and rebuilt at Detroit during the winter of 1887–88, when it was renamed the *City of Sandusky*. This replaced another vessel of that same name that was destroyed by fire in March 1876.

The *City of Sandusky* remained in service until 1894. That December, the machinery was stripped at Detroit. The boilers were installed aboard the new steamer *Arrow*, which was launched the following spring. Afterward, the former *Jay Cooke* was sold for old lumber and scrap iron.

STEAMER *ARROW*

As previously stated, the *Arrow* was powered by the former *Jay Cooke*'s steam engine. Construction of this new vessel was well underway by the end of 1894.

The *Arrow* was built for the Sandusky and Island Steamboat Company under the direction of president Andrew Wehrle of Middle Bass Island. It was designed by Frank Kirby and built at the Detroit Dry Dock Company in Wyandotte, Michigan. It was a three-decked, steel-hulled vessel and was a side-wheel steamer. The *Arrow* measured 165 feet long, 28 feet wide and had a 10-foot draft. The overall weight was 365 gross tons. It was said that the *Arrow* could carry upward of nine hundred passengers.

Placed in service before the end of the spring of 1895, the *Arrow*'s first captain was George A. Brown of Sandusky. Throughout the season, it would make regular runs from Sandusky to Put-in-Bay, Kelleys Island and Middle Bass. Like its larger sister, the *Frank E. Kirby*, the *Arrow* also carried the U.S. mail to the islands and produce to the markets.

It should be noted that this wasn't the first vessel called *Arrow* on Lake Erie. Another steam vessel of that name traversed the lake from 1848 to 1863 and occasionally made stops at Put-in-Bay. One such visit saw an event of very historic proportions in 1852, which is discussed in the next chapter of this book.

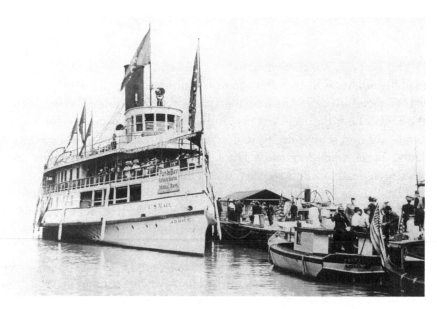

An undated photo of the steamer *Arrow* at Put-in-Bay. *Courtesy Dan Savage.*

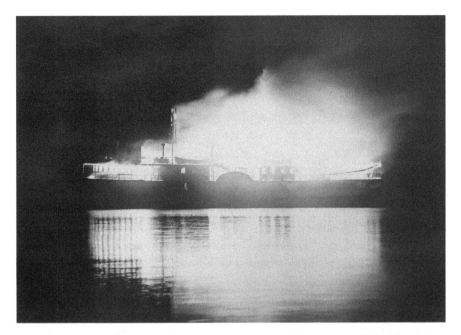

Fire aboard the steamer *Arrow* at Put-in-Bay on the night of October 14, 1922. *Courtesy Dan Savage and the Lake Erie Islands Historical Society Museum.*

The *Arrow* had a run that lasted just twenty-seven years. It burned while moored at Doller's Dock on Saturday, October 14, 1922. The fire started just before midnight in the cabin. When the flames were noticed, the crew was awakened by the watch, and an immediate attempt was made at extinguishing the blaze. Realizing that their efforts were in vain, the crew abandoned ship. To save the dock, the *Arrow* was cast adrift and set out into the harbor, where it spectacularly burned against the night sky. By dawn, the *Arrow* had completely burned down to the hull, which was the only part salvageable. Losses were estimated at $80,000, and a cause of the blaze was never determined.

The hull was sold in 1923 to the North Shore Steamship Company, was rebuilt in Sandusky and departed the Lake Erie Islands to make runs from Chicago to Waukegan. In 1931, the *Arrow* burned on the North Branch of the Chicago River. Following the fire, it was towed to Sturgeon Bay, where in 1936 it was stripped down to a barge. A crane was installed, and for the next two years, it operated out of Monroe, Michigan.

In 1938, the *Arrow* was sold to Benjamin O. Colonna, who took it to the Intracoastal Waterway, where it was used in salvage operations near Norfolk, Virginia. In 1942, the *Arrow* was brought to Jacksonville, Florida, where a

diesel engine was installed. The following year, it was sold to a shipping company out of Puerto Cortés, Honduras. It was re-registered as motor vessel *H-165* and was used in the banana trade. On October 26, 1946, it was wrecked on Barrier Reef, nine miles north by northeast of the Hunting Caye Light in Honduras.

THE TIN GOOSE

The Ford Tri-Motor was the first mass-produced aircraft to be used for commercial airline service. Because of its sluggish appearance while taxiing, it was nicknamed the "Tin Goose" and was sometimes called the "Flying Washboard" owing to the corrugated aluminum surface of the fuselage.

There were a number of variations of this aircraft. The model 4-AT-B was the same model of aircraft that was used by Richard Byrd to fly over the South Pole in 1929. It had a seventy-six-foot wingspan, was fifty feet in length and had an average cruising speed of eighty-five miles per hour. There were seats for fifteen passengers and one pilot. It was originally installed with leather-cushioned wicker cabin chairs, while polished wood paneling was found throughout the cabin.

For many years, a small fleet of these Ford Tri-Motors serviced the Lake Erie Islands under the banner of Island Airlines. This story will specifically trace the history of one of those airplanes, *N7584*, which was the first and last to regularly service the islands.

N7584 was built in 1928 and was the 38th of 198 Tri-Motors built at Dearborn, Michigan. It was originally equipped with three 220-horsepower, Wright J-5 Whirlwind engines, but these were changed out in later years for Wright 760A B D E&ET engines.

It began its service for the Robertson Aircraft Corporation of Anglum, Missouri. After only one or two seasons, it was shuffled around to various airlines. It next went to Universal Aviation in St. Louis, then to American Airways in Robertson, Missouri (formerly Anglum), then on to Air Services in Pittsburgh.

Meanwhile, at Put-in-Bay, a forty-three-year-old test pilot and barnstormer named Milton "Red" Hersberger was establishing an air service to the islands. In November 1930, he opened an airport on South Bass Island and began flights in an open-cockpit aircraft under the name Lake Erie Airways. Within a few years, it was operating under the name Air Tours, Inc.

In December 1936, *N7584* was purchased by Hersberger and brought to South Bass Island. The following season, the Tri-Motor was making two daily flights around the islands. By 1947, Hersberger had a fleet of four Tri-Motors, ultimately owning a total of seven throughout his lifetime.

By the 1950s, Air Tours had changed its name to Island Airlines. At that point, the fleet was painted white with red and blue trim. Island Airlines was billed as the "Shortest Airline in the World." It departed from Put-in Bay and serviced Middle Bass, North Bass, Kelleys and Port Clinton before returning to Put-in-Bay. The total flight plan covered a distance of about eighteen miles. Occasional stops were made at the private field on Rattlesnake Island. Eventually, the airline was running twelve round-trip flights daily to the islands during the summer months, more sometimes if the demand was there. It operated four daily flights the rest of the year.

Upon the retirement of Hersberger in 1953, operation of the airline was taken over by Sky Tours Inc. of Sandusky and Port Clinton. Also, three of the four Tri-Motors were sold, leaving only *N7584*.

A popular pastime for some area vacationers was racing the Tri-Motor to the point. Most would think that an automobile wouldn't stand a chance against an aircraft, but then, this was the Tin Goose. Once the aircraft crossed Route 163 on its way north to Put-in-Bay, the race would start. From

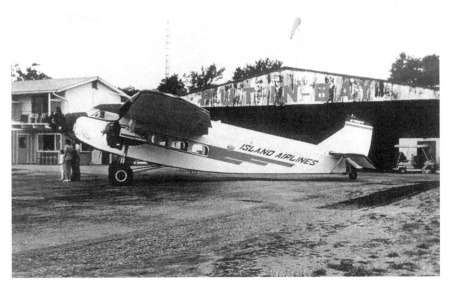

Island Airlines Tin Goose *N7584* at Put-in-Bay Airport. *Courtesy of the Lake Erie Islands Historical Society Museum.*

Island Airlines Tin Goose *N7584*, which crashed at Put-in-Bay just after takeoff on July 1, 1977. *Courtesy Arthur Boyles.*

the intersection, the driver of the car quickly proceeded north on Route 53 and tried to beat the plane to Catawba Point, a distance of almost five miles. If there was a strong enough north wind, the car sometimes won.

In 1975, the Monogram model company issued a limited-edition 1:77 scale model of this exact aircraft. After seeing its success, the model was reissued in 1978. In 2012, an updated version was released.

The famed Ford Tri-Motor enjoyed nearly fifty years of successful service, but everything changed on July 1, 1977. It was on that day, while taking off from Put-in-Bay, that the Tin Goose was involved in a serious crash. According to the FAA and NTSB, the cause of the crash was from fuel suspension. Heavy turbulence on takeoff caused the fuel to splash around in the gravity-fed tank, allowing air to be sucked into the fuel lines. This caused the central engine on the nose of the aircraft to stall out during the climb. Pilot Dave Martin attempted to return to the airport when another engine quit. Immediately after, the aircraft banked and struck a telephone pole and wires, which ripped off the starboard wing and ended the flight in a nearby field. Dave Martin received severe injuries to his back, hip and pelvis. Of the two other passengers aboard, one injured their finger while the other was unharmed.

Within two hours of the crash, Island Airlines president Dave Haberman decided to rebuild, despite advice from others. While the insurance on the aircraft was $75,000, the cost of repairing the plane was four times that amount. Restored, it was valued at $1 million. The repairs were made by the Kal-Aero Company in Kalamazoo, Michigan. By the spring of 1980, the Tin Goose was back at the islands, and Dave Martin was again at the controls.

Senior pilot Harold Hauck, who logged more than 18,200 hours, once said that they carried more than just passengers in the Tin Goose; they would transport pretty much anything that they could get into the plane. One time, they even carried a bathtub to the islands.

Island Airlines closed in 1985, and the following year, *N7584* left the islands. The new owner kept the Tin Goose in Homestead, Florida, where it was severely damaged by Hurricane Andrew in 1992. When the storm hit, it was secured in a hangar, but the roof blew off and the Tri-Motor was tossed around like a leaf in the wind. At first, it was written off as a total loss, but it was later transported to Vicksburg, Michigan, where it was restored by Hov-Aire, Inc. In 2014, it received its certificate of airworthiness. This begs the question, will *N7584* ever see the islands again?

VICTORY PARK ELECTRIC RAILROAD

While the Put-in-Bay Hotel Company was established by James Tillotson to secure funding for the Hotel Victory, a separate entity was set up to supply power and water to the establishment and surrounding cottages. At this, the Put-in-Bay Water Works, Light and Railway Company was incorporated in 1890. It was also put in control of establishing a trolley line to bring guests from the downtown docks to the island resort. It received the green light for this service in early 1891, though more than eighteen months passed before the project saw completion.

The traction railroad was first intended to run as a double track from downtown at the Doller Dock, along the bay to West Shore and from there out to the Hotel Victory. Its return trip to the village would take riders down Catawba Avenue, with a stop at Perry's Cave. It was even proposed that a spur extend east down Bayview Avenue, across the front of DeRivera Park and end at the dock now occupied by the Jet Express. Only the Catawba Avenue line was built.

The track started on the east side of Catawba Avenue, across the street from the Doller Building, today's Mossbacks and Fishbowl. With a clickety-

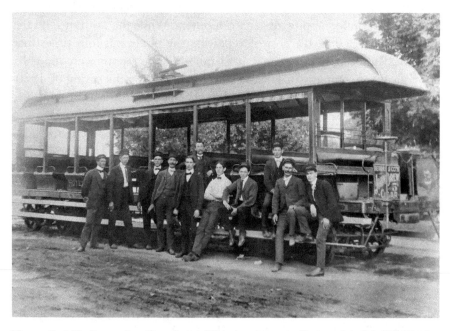

Victory Park Trolley no. 3 at Catawba and Bayview Avenues. *Courtesy of the Lake Erie Islands Historical Society Museum.*

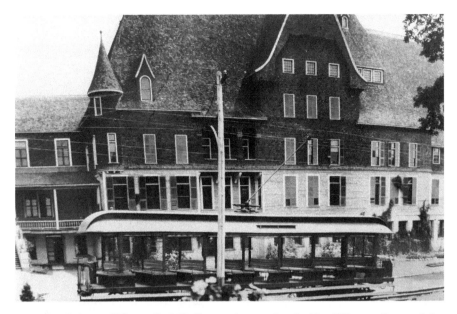

An undated photo of Victory Park Trolley no. 4 stopped at the Hotel Victory. *Courtesy of the Lake Erie Islands Historical Society Museum.*

clack, its wheels rolled out toward the Victory. At the bend in the road at Erie Street, the tracks crossed over to the west side of Catawba Avenue. It made one stop along the way, and that was outside Perry's Cave. It was there that a siding was placed so that the village-bound and hotel-bound trolleys could pass each other. After the siding, the trolley line crossed a low area beside the road on a small trestle and continued on toward the hotel. At the corner of Catawba and Niagara, the line made a wide right turn onto Niagara Avenue. As it approached Schiele's Castle, the line split. One spur turned left immediately after Crown Hill Cemetery, entered the grounds of the Victory and terminated in front of the hotel.

The other line continued on Niagara Avenue until just after the Schiele property, where the tracks turned to the right and terminated at the car barn, a good five hundred feet from the hotel. That building also housed the powerhouse for the electric railroad and supplied power to the hotel and cottages at Victory Park. It was a steam-powered plant that ran on the Westinghouse system. It had two 150-horsepower dynamos for the railroad. Two 300-horsepower Russell engines produced electricity for the hotel and grounds.

The Victory Park Electric Railroad was equipped with four motor cars and four trailers of the same size. All were forty-foot-long, open-sided cars. Each

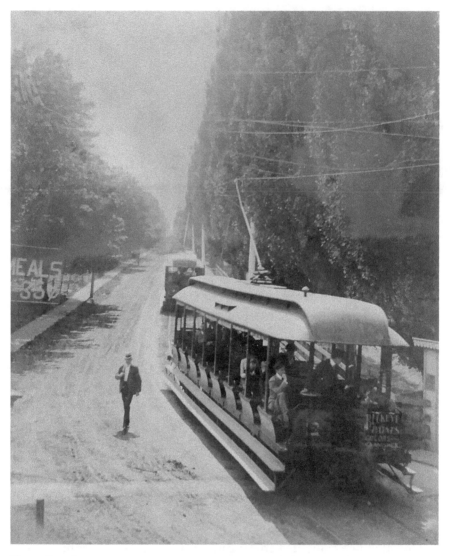

Victory Park Trolley nos. 4 and 2 at Catawba Avenue and Erie Street. *Courtesy of the Lake Erie Islands Historical Society Museum.*

car had fourteen inside benches and could seat ninety people. An outside front and rear bench were reserved for the conductor and motorman. When the trolley reached the end of the line, the motorman and conductor simply switched positions for the return trip. The motor cars could be driven from either end.

If the traction company had gone ahead with the original plan of taking the line in a loop and running along West Shore, the total amount of track laid would have been around four miles. As it was, the total length of track that ran from the Doller Dock to the Victory was just over one and a quarter miles long. Just as much electrical cable was needed to power the cars. With caves opening as tourist attractions along the trolley line in the late 1890s, many of these tapped into the newly strung wires to illuminate the caverns. Prior to this, the caves were lit with oil lamps.

The electric railroad continued to run during the seasons that the Hotel Victory was in operation. During those years that it was shuttered, so, too, was the trolley. With the reopening of the Victory in the spring of 1919, the traction railroad resumed service. Following the fire that destroyed the Victory that August, George Gascoyne and Gustav Heineman, who respectively owned Perry's Cave and Crystal Cave, continued operation of the Victory Park Electric Railroad until around 1921. Not long after, the line was abandoned and the tracks were ripped up and sold for scrap.

Chapter 4

ATTRACTIONS

STEP RIGHT UP

Attractions abound on South Bass Island, today as much as ever. Though they may be gone, laughter from the roller coasters and water toboggans of yesterday can still be heard on the evening wind, like a ghost of the past casting a spell of nostalgia on the island. Climb the monuments to Perry that never came to be and delve deep into island caverns of Cimmerian darkness, long since closed, where hushed voices of long ago still echo and whisper in dulcet tones.

DAUSSA AND MAMMOTH CAVE

Among the attractions of South Bass Island are its famously known caves. Today, only two caves are in operation. Perry's Cave is a vast underground space where guided tours lead visitors down a stony path, through the great room, to a lake located in the back. The water of the lake is crystal clear, but not drinkable, due to its high copper content. This was caused by a century of visitors throwing pennies in and treating the natural wonder as a wishing well. Perry's Cave Family Fun Center is also the home of the Butterfly House, War of 18 Holes Mini Golf, Fort aMAZE'n, gemstone mining, a rock-climbing wall and the free Antique Car Museum.

Across the street from Perry's Cave is the fifteen-thousand-year-old Crystal Cave at Heineman's Winery. Like Perry's Cave, this island attraction has been welcoming guests for over a century. Unlike the other caves on the island, which are limestone caverns, Crystal Cave is a large hollow rock called a geode. In fact, it's the largest known geode on Earth. The dazzling interior, which is spacious enough to hold around thirty visitors, is lined with massive strontium sulfate crystals, made up of a pale blue mineral called celestite. Most crystals range between eight and eighteen inches in length. The largest, if extracted, would weigh several hundred pounds. Visitors to Crystal Cave are also treated to a sample of either wine or grape juice. Also included is a tour of the winemaking facility, Ohio's oldest family-owned winery, which dates back to 1888.

Both Perry's Cave and Crystal Cave are definite must-see attractions when visiting Put-in-Bay. All in all, there are about twenty-seven caves on South Bass Island. One or two are located along publicly accessible wooded paths, but most are on private property. Here's the story of one island cave that's no longer accessible to the public.

Opened as Daussa's Circular and Labyrinthic Cave, this island attraction was also a popular must-see and was in operation for a little over fifty years. It's been claimed that Daussa Cave was first discovered in 1886. Observations of ash deposits throughout the cave, however, indicate its use by earlier people. When observed in 1886, the entrance was very small, being only a little larger than an animal's burrow. Upon exploration, it was discovered that the hole led to a massive underground space full of stalactites and stalagmites. At the time, the property was in the possession of Joseph de Rivera.

Upon the death of de Rivera in 1889, the property passed to his widow, Rachel. Since de Rivera's estate was still in debt over the failure of his company, Rachel was forced to sell the land. It was purchased on January 18, 1894, by her and Joseph's son-in-law, Dr. Augustin Daussa of New York City.

Dr. Augustin Francisco Juan Daussa was born in Girona, Spain, in 1837. He came to the United States and in time was engaged as a proprietor of the American Vermicelli Company in New York with his elder brother, Pedro. On February 22, 1885, he was married to Casilda de Rivera, Joseph and Rachel's only daughter.

Augustin Daussa owned the cave for only two years. He died on March 15, 1896, at the age of fifty-eight. Casilda died quite suddenly only two months later on May 14 at the age of forty. Both were laid to rest in the Daussa family mausoleum at Woodlawn Cemetery in the Bronx, New York. Following the

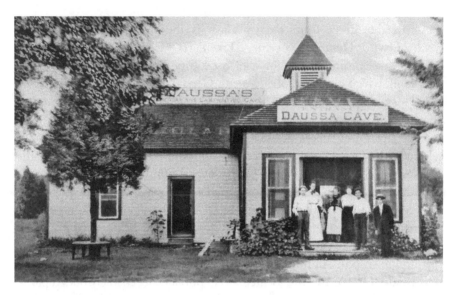

An undated postcard showing the entrance to Daussa's Circular and Labyrinthic Cave. *Courtesy Heineman's Winery.*

untimely passing of Augustin and Casilda Daussa, the property was passed to Augustin's brother, Pedro.

Daussa Cave was composed of two large caverns and a small circular passage that ran between them. This passage, however, was too small to permit visitors access. In 1898, dynamite was employed and the passage was enlarged by a few feet at its closest points, making it passable for guests. Also, most of the stalactites and stalagmites were removed at that time to further open the pathway. Other formations were taken as souvenirs.

Improvements, such as electric lights and stairwells, were added to the tunnel in May 1899. Also added to the property was an entrance building for the cave and a covered shelter on the corner, across the road from the trolley stop at Perry's Cave. The following month, the cave was opened to the public.

The entrance to Daussa Cave led visitors down two flights of stairs, forty feet into the earth, where they stepped into a Plutonian realm of wonders. They first came to an underground lake of crystal-clear water, where the reflections of electric lights shimmered and danced on the surface. This lake measured eighty feet in length and was forty feet across. The water level rose and fell with the height of Lake Erie; this is a common trait shared by all underground lakes on South Bass Island. What set this one apart from the others was that it had a four-foot drop to a small sandy shore. Guests

passed the lake on a wooden boardwalk that offered bench seating. The lake contained many submerged stalagmites. It's impossible for these to form under water. This gave rise to the theory that the land at the western end of Lake Erie was sinking. Another and more likely theory put forward a few years later claimed that the lake level was much lower at the time these formations were created.

From the lake, subterranean explorers entered a five-hundred-foot-long, horseshoe-shaped tunnel that wrapped around to the southeast and gradually sloped upward. Along the way, guests passed two chambers that sat opposite each other. These were discovered just prior to the cave's opening. Their stalactites and stalagmites remained untouched by earlier specimen hunters. The long tunnel emptied into a huge cavern where rock formations with names like "The Alligator" and "The Turtle" could be found. On the north end of the cavern were steps that led to the exit. Visitors emerged from their underground sojourn a great distance from the entrance building.

Pedro Daussa died on February 28, 1903. The cave property then passed to his nephew Luis August Daussa and his wife, Hortensia, in 1907. They signed a quitclaim deed to Mathias Ingold in 1911. That year, a land contract was signed to Martin Daussa for $15,000.

In 1913, Daussa Cave was purchased by the Put-in-Bay Resort Company, of which Mathias Ingold was a director. As the Daussa family was no longer involved in the venture, the name was changed to Mammoth Cave. Gustav Heineman, another director of the Put-in-Bay Resort Company, took over

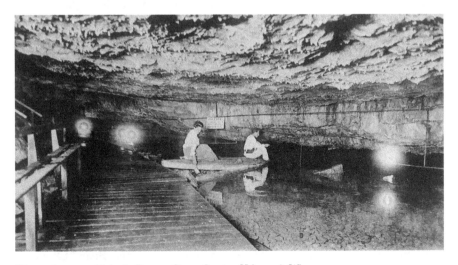

The underground lake in Daussa Cave. *Courtesy Heineman's Winery.*

management of the concern. Upon his death in 1934, operations were assumed by his son, Norman.

Due to a dangerous rock collapse that occurred over the winter, Mammoth Cave was closed to the public at the start of the 1953 season and has remained so ever since.

The entrance building to this cave is still standing on the northeast corner of Catawba Avenue and Thompson Road, across from Heineman's Winery and Perry's Cave. It sits on the grounds of a private residence, is private property, and it is therefore strictly off limits.

PARADISE CAVE

Located 550 feet south of Perry's Cave, along Catawba Avenue, was Paradise Cave. This cavern was discovered in 1903 by William John Kindt, who had purchased the lot eleven years earlier from the Barsch family. Kindt, a German immigrant and grape grower who came to the island in 1885, lived in a house on the property just a few feet from the cave's entrance, and for more than a decade, he was unaware of the cave's existence. The house that he and his family occupied was built by Martin Barsch in the mid-1870s. Barsch likewise never observed the cave, even though it was right there in his front yard, just beside the road.

Like Perry's and Daussa, Paradise Cave was a limestone dome cave with a lake located in the back. After a descent of 24 feet, visitors found themselves in a room measuring 250 feet long and 30 feet wide.

William Kindt built a small entrance building beside the road and charged ten cents for admission. From the building, guests descended a wooden stairwell into the depths of the cave. The walkway that wound through the cave was lined with a net, preventing visitors from breaking off the natural formations and collecting souvenirs. During Kindt's ownership, Paradise Cave was lit with oil lanterns.

Like the two side chambers in Daussa Cave, many of Paradise's stalactites and stalagmites remained intact and untouched. This offered one of the best places to view such formations. Some stalactites measured as long as thirty-two inches. As was a popular trend in the day, certain rock formations were given names based on their resemblance to other items. Paradise had formations with names such as "The Fish" and "The Polar Bear." One that was a huge draw was the "Petrified Angel," a stalagmite that appeared to have

The entrance to Paradise Cave on Catawba Avenue. *Courtesy Rutherford B. Hayes Presidential Library & Museums, Charles E. Frohman Collection.*

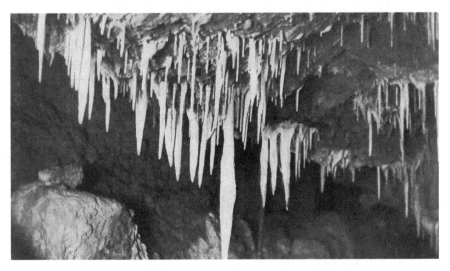

Massive stalactites in Paradise Cave, circa 1905. *Courtesy Heineman's Winery.*

wings. The tradition of naming cave formations continues today in Perry's Cave, where a stone hump called "Homer Simpson" may be observed.

Following the death of William Kindt in 1912, the cave was managed by his widow and their children. In November 1915, the property was sold to Charles Czuckowitz of Cleveland, who sold it to the directors of the Put-in-Bay Resort Company the following spring. That year, Paradise Cave was illuminated with electric lights.

The Put-in-Bay Resort Company continued to operate Paradise Cave until the late 1930s. When it was closed, the entrance building was torn down. Though it is sealed, remnants of Paradise Cave can still be observed in the front yard of the old Kindt home near the intersection of Catawba and Trenton Avenues. Like the former Daussa Cave, Paradise is entirely on private property and is therefore strictly off limits.

THE CASINO AT PERRY'S CAVE

Perry's Cave has been drawing visitors to the island for over two centuries. It was mentioned in a journal from 1813 as having been visited by Perry's men, who used its subterranean lake as a source of purified drinking water prior to the Battle of Lake Erie. Before that, men in the fleet were drinking water directly from Lake Erie, which even in those days wasn't recommended. Had it not been for this cave, or specifically the lake it contained, it's possible that most of the personnel in Perry's squadron might have been too sick to fight, let alone win the famous battle. History might have gone very differently.

A visit to the fascinating depths of Perry's Cave is truly an experience to remember. After a descent of 52 feet, visitors enter a vast cavern measuring 280 feet in length and 164 feet at its widest point. The previously mentioned underground lake is located in the back, as is a smaller chamber called "Perry's Bedroom." That chamber has a narrow passage leading back into the main cavern, called "Fat Man's Misery."

Perry's Cave was originally owned by Joseph de Rivera but was first operated by Phillip Vroman. Upon opening the cave as a tourist attraction, Vroman built a small building over the entrance that measured fifteen feet by thirty feet. At the time, this was more than adequate for its purpose.

Meanwhile, in 1895, two men named Thomas Webb and William Stimmel purchased the two acres of land that adjoined the eastern end of DeRivera Park. These two acres had been retained by Joseph de Rivera

when he deeded the park to the village. With his estate in debt and forced to sell land, this lot was also put up for sale. Shortly after making their purchase, Webb and Stimmel constructed a new building that sat on the northerly edge of their lot. Resting on a stone and mortar base, this building extended from the shore directly out into the bay.

Opened as the Rivera Party Rooms, it was a two-story wooden structure that measured 80 feet wide and 50 feet deep. It adjoined a small boathouse and the walkway that led from the steamer dock to the Beebe House. The first floor had a bar and a banquet hall that measured 30 feet by 50 feet. On the second floor was the 1,200-square-foot ballroom. The Rivera Party Rooms opened in the spring of 1896 and advertised free tables and free dancing.

Claims in recent years state that this building was, for a time, also called the Lookout. This is completely erroneous and stems from a photo of the building that also happened to show the Observation Tower in the background, which was called the Lookout.

In the spring of 1899, the Village of Put-in-Bay, through eminent domain, took possession of the Webb and Stimmel property and annexed

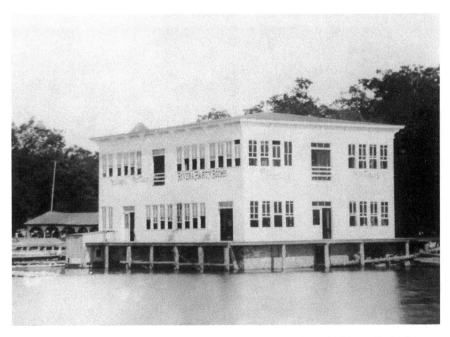

The Rivera Party Rooms were built directly on the bay across from DeRivera Park, circa 1890s. *Courtesy Dan Savage and the Lake Erie Islands Historical Society Museum.*

it to DeRivera Park. The men were paid fair market value for the property, and the Rivera Party Rooms were purchased by island builder George Gascoyne and Put-in-Bay mayor Valentine Doller, who then owned Perry's Cave. The building was dismantled and rebuilt above the cave's entrance where the previous building had stood.

As was the case when situated on the bay, the Rivera Party Rooms building, which was now operating under the name of the Casino, kept the dance hall on the second floor, while the dining hall and barroom were located on the first. The cave entrance and gift shop were also located on the lower level.

One of the reasons that Doller and Gascoyne had this building moved to that location was to contend with the newly opened Daussa Cave and Crystal Cave across the street. As an entertainment complex and tourist attraction, the Casino opened to the public with a dance on July 15, 1899.

For the better part of the next twenty years, the Casino continued in successful operation. Many dances were held there, as were occasional vaudeville-style performances and social gatherings. With the start of Prohibition, the Casino closed. The cave remained open, of course, but the dance hall and bar were shuttered indefinitely. At this, the upstairs dance hall was converted into a storage space.

The Rivera Party Rooms later became the Casino at Perry's Cave. *Courtesy Dan Savage and the Lake Erie Islands Historical Society Museum.*

The Casino building was destroyed in a fire that tore through the structure on the night of September 30, 1932. Destroyed with the Casino were the items that were being stored in the old dance hall on the second floor. Among those items were the model of the original concept of the Perry Memorial that was unveiled in 1912. Another item stored on the second floor was the catafalque that was used in September 1913 to transport the remains of the fallen officers from their original burial site in DeRivera Park to the rotunda of the memorial.

Not long after, George Gascoyne replaced the Casino with a two-story structure. The original site of the Rivera Party Rooms on the bay was the area between B and C docks, just to the west of the Jet Express dock and the downtown boat ramp.

FIRST PERRY'S MONUMENT

It will be remembered that, following the Battle of Lake Erie, the enlisted men killed in the action were stitched up into their hammocks and buried at sea with a cannonball to weigh them down. Two days later, the slain officers were buried on land at Put-in-Bay. Three American and three British officers became casualties and were laid to rest in one grave. They had been enemies in life but were seen as equals in death. It was said that Perry himself snapped off a branch from a nearby willow tree and planted it at that burial site. That branch took root and grew into what would be known as the Perry Willow.

In all actuality, that willow tree could be considered the first true monument to those who fell in the battle. Trees, no matter how long they live, aren't permanent. For many years, talk of erecting a stone monument to Perry and the Battle of Lake Erie was in circulation, but decades passed before any steps were taken toward making one a reality.

One of the earliest people in the area to propose the placement of a monument to Perry was Dr. Robert Richie McMeens of Sandusky. Dr. McMeens was born in Pennsylvania but came to Sandusky in 1849 during the tragic cholera outbreak that devastated that city. Three years later, he organized a military encampment on South Bass Island to mark the Independence Day holiday. A fateful decision was reached that weekend.

On July 5, 1852, the Battle of Lake Erie Monument Association was organized at Put-in-Bay. Out in the harbor, a meeting was held aboard the

steamer *Arrow*, the earlier vessel to bear that name. A motion was made by Pitt Cooke to appoint a committee of five people to draft resolutions for building a monument on Gibraltar Island in commemoration of Perry's Victory at the Battle of Lake Erie and in honor of the dead who fell in that memorable engagement. Afterward, a constitution was written and adopted. It should be noted that Pitt Cooke's brother Jay purchased Gibraltar Island twelve years later.

General Lewis Cass, former governor of the Michigan Territory, was chosen as president. Twenty-five vice presidents were also chosen. A few names of note among them were Ohio governor Reuben Wood and Captain Stephen Champlin, first cousin of Commodore Perry, who commanded the U.S. schooner *Scorpion* at the Battle of Lake Erie. Alfred Pierpont Edwards, who owned the islands at that time, promised to cede the land necessary for the proposed monument. The committee raised $1,500 in cash that day, but that money went no further. A few more years passed before the next steps were taken.

On September 10, 1858, the forty-fifth-anniversary commemoration of the Battle of Lake Erie was held at Put-in-Bay. Thousands were in attendance. Among the guest speakers were three who served at the battle, those being the previously mentioned Stephen Champlin, along with Thomas Brownell, who was sailing master aboard the U.S. schooner *Ariel*, and Dr. Usher Parsons, acting surgeon of the fleet. Commemoration services were held in the grove that later became DeRivera Park, just a few feet from the old willow that marked the graves of the six fallen officers. At that event, a push to finally build the Perry Monument was renewed, and plans were made to proceed the following spring.

In March 1859, plans for the construction of the memorial were announced. The original concept was designed by Joshua Brown Merrick, a Sandusky architect. The proposed design called for an Egyptian obelisk, the shaft of which was 109 feet, 6 inches in height, 15 feet square at the base and 11 at the summit. It sat on an 18-foot-high foundation that measured 23 feet square. There were to be numerous windows placed on all sides of the shaft. An iron spiral staircase was to ascend the interior of the column.

It's uncertain if the committee was dissatisfied with J.B. Merrick or, specifically, his plans. What's known is that the proposed obelisk was abandoned and another designer was sought. That May, a sculptor from Columbus named Thomas Dow Jones was commissioned by the executive committee to execute a design for the memorial. Jones had an extensive career and was a more prominent figure in his day.

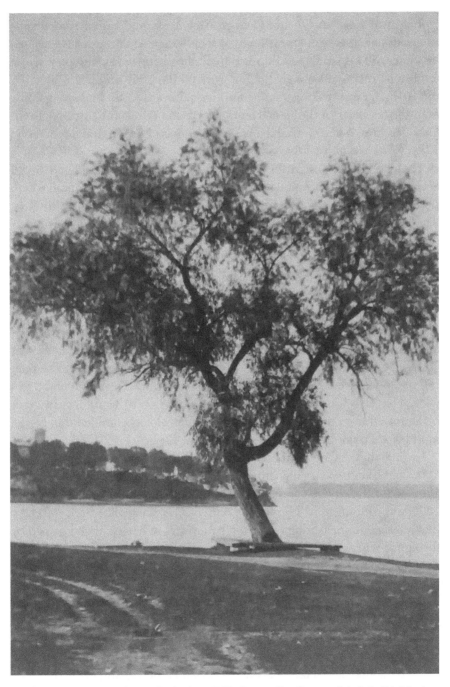

The Perry Willow in DeRivera Park, circa 1865. *Courtesy Dan Savage and the Lake Erie Islands Historical Society Museum.*

Jones was born in Oneida County, New York, and began work in the stonecutting industry at an early age with his father. At the age of twenty-six, he came with his family to Ohio and spent the next few years employed as a tombstone carver, eventually finding work on the Ohio and Erie Canal. By the 1840s, he was making a name for himself as a sculptor and was gaining note for his busts of William Henry Harrison, Winfield Scott and Lewis Cass. His most noted work is the bust of Abraham Lincoln that he carved in 1871, which sits in the Ohio Statehouse.

Thomas Jones's design for the Perry Memorial was considered by all accounts to be entirely unique and naval in every aspect. The column was to represent the mast of a ship, with portholes and draping shrouds at the base. The upper capital was to be of the Corinthian order. The four corners of the observation deck would be formed by the bows of four vessels pointing in the four directions. Just below these were shells and crashing waves, which would replace the acanthus leaves commonly found on Corinthian columns. At the center of the observation deck, a ship's capstan was to be placed, with an eighteen-foot statue of Commodore Perry mounted at the center.

The monument was to be erected at a point on Gibraltar Island 40 feet above the lake. The height of the memorial column itself was planned at 160 feet, giving it a total height of 200 feet. The monument was to be built of limestone, except for a piece of marble, measuring 5 feet high and 8 feet wide. That slab was to contain, in relief, a depiction of Commodore Perry being rowed from the *Lawrence* to the *Niagara*, which is considered to be the most pivotal point in that naval engagement.

During this era of national patriotism when the Perry Memorial for Gibraltar Island was being proposed, a competing monument was being planned for the city of Cleveland. That monument, unveiled in September 1860, was contracted to T. Jones and Sons of Cleveland. The statue of Perry that adorned it, measuring eight feet, two inches in height, was designed by the famed sculptor William Walcutt.

Despite popular belief, Walcutt only designed the statue and carved a plaster likeness that was used as a template. He did not carve the statue itself. That work was done by a twenty-six-year-old Irish-born artisan named John O'Brien of John O'Brien & Co., Sculpting and Marble Works, located at 44 Michigan Street in Cleveland. O'Brien studied sculpture throughout the 1850s in Rome before coming to the United States. Following his work on the Perry statue, he established studios in San Francisco and Galveston.

The marble that composed that statue was shipped to Cleveland from Carrara, Italy. This was Ohio's first public monument. After being moved

to several locations in multiple cities over the years, the statue of Perry ultimately found a home in 2002 in the visitors' center of Perry's Victory and International Peace Memorial. It's also featured on the back of a U.S. quarter that was released in 2013.

It should be noted that Thomas Jones, who was the head of the firm T. Jones and Sons, was not the same Thomas Jones who was tapped to design the monument to be built on Gibraltar Island. The fact that the men hired to design these two monuments to Perry shared the same name is purely coincidental.

When the original plan for the Perry Memorial on Gibraltar Island was presented, it was done so in accompaniment of a watercolor painting of the plans, showing landscaping and scenery. This was accomplished by Cincinnati artist Henri Lovie. Early in his career, Lovie established himself as a landscape designer and portrait artist. By the 1850s, he was gaining acclaim as an illustrator of note. He's most known for his paintings of Civil War battlefields and the aftermath found thereupon.

On Saturday, September 10, 1859, a crowd of nearly twenty thousand again assembled at Put-in-Bay for the commemoration of the Battle of Lake Erie. It had rained in the morning, but the clouds soon gave way to beautiful skies and temperatures neither too warm nor too cold. No fewer than eighteen steamships were present in the harbor, a spectacle rarely seen at any port on the Great Lakes.

Early in the afternoon, visitors to the island took their lunches in the village grove, while brass bands performed and banners flapped in the gentle late-summer breeze. A stand had been erected at the north end of the grove near the bay, where the officers of the Monument Association were gathered. Among them were four veterans of the battle, those being Dr. William Taliaferro, William Blair, John Tucker and Benjamin Fleming. At 2:00 p.m., the services started with the orator giving comments on the battle, the events that unfolded during the engagement and what transpired after. This was followed by a report from the Monument Association, a song and the benediction.

From there, the crowd made its way to Gibraltar Island to witness the cornerstone-laying ceremony. Present with the officers of the association were Masons from the Grand Lodge of Ohio. The master workman pronounced the cornerstone as being "Tried, True, and Trusty," and the stone was set by Grand Master Horace M. Stokes.

And there the cornerstone sat for the next few years, with no monument placed upon it.

SECOND PERRY'S MONUMENT

In order to tell this part of the story, one must be properly introduced to Jay Cooke, who would have a significant influence over the direction of Gibraltar Island in the years to come.

Jay Cooke was born in Sandusky, Ohio, on August 10, 1821, to parents Eleutheros and Martha Caswell Cooke. At fourteen years of age, he started work in Sandusky at a dry goods store but within a few years became a clerk and later a partner in the banking firm of E.W. Clark and Company in Philadelphia. In 1860, he founded the firm Jay Cooke & Company, which was responsible for having issued more than $1 billion worth of war bonds for the United States during the Civil War. In later years, he became the founder and financier of the Northern Pacific Railroad.

In 1864, Jay Cooke purchased Gibraltar Island from Joseph de Rivera for $3,001. When de Rivera proposed the sale price of $3,000, Cooke told him, "I'll do you one better"; thus, they arrived at that odd figure. He spent significantly more on the construction of his summer residence that would grace the island, building what became known as Cooke's Castle, at a cost of $30,000. Well into the following year, plans were still on the table to erect the monument on Gibraltar, though the island had been purchased by Cooke.

Then, in April 1866, it looked as though the monument would finally take shape. It was reported at that time that Thomas Lawrence was engaged at Gibraltar Island erecting a monument to Commodore Perry. Lawrence, a forty-two-year-old Irish immigrant, was for many years a reliably known stonecutter in Sandusky. Without the assistance of the Battle of Lake Erie Monument Association, this new monument was being paid for by Jay Cooke alone. It was believed that, by the end of the summer, a "splendid marble column" was to have been completed on the small island, but this was not to be.

The work went no further than the placement of an ornate sculpture that was to be a cornerstone for a future monument. This was placed directly atop the previous cornerstone that was set on September 10, 1859. It was a large white stone topped by a bronze urn. On the two broader sides of the stone were placed bronze reliefs, bearing two crossed swords and two crossed axes on an anchor, adorned with a laurel wreath. The two narrow sides each bore a plaque that read:

Erected
By
JAY COOKE
PATRIOTIC FINANCIER
OF THE
CIVIL WAR
TO MARK THE
CORNER STONE OF A
PROPOSED MONUMENT
COMMEMORATING
COMMODORE PERRY'S
VICTORY AT THE
BATTLE OF LAKE ERIE
SEPTEMBER 10, 1813
"WE HAVE MET THE ENEMY
AND THEY ARE OURS"

A sealed box was placed beneath the new cornerstone by Ann McMeens, wife of Dr. Robert McMeens, who had first organized the military encampment at Put-in-Bay in 1852. Dr. McMeens served as a surgeon in the 3rd Ohio Regiment and died of illness during the Battle of Perryville, Kentucky, on October 30, 1862. The box that his widow placed beneath the new cornerstone was sealed by her late husband some years earlier while he was secretary of the Monument Association. Its contents were not disclosed.

In 1869, *The Pictorial Field-Book of the War of 1812* was published by Benson J. Lossing. The tome accounts for almost every event that occurred throughout that conflict and was illustrated with detailed engravings. Among them is a depiction of the later proposed monument, the splendid marble column that was to be built on Gibraltar Island. The image shows a narrow shaft reaching into the night sky, topped by what appears to be a statue of Perry. Also in the image is the famed rock formation known as Needle's Eye. A few grave markers, presumed to be those of James Ross and John Elliot, are set in the foreground. It would appear, though, that the illustrator hadn't actually visited Gibraltar Island in person, as he placed the full moon low in the northern sky, a place it would never be seen.

That same year, the Monument Association again hosted a commemoration of the Battle of Lake Erie at Put-in-Bay. Only three known survivors of the battle were scheduled to give reminiscences on the event. It was hoped that the association would be able to secure further funding for the completion of

Cornerstones for the first and second proposed monuments to Commodore Oliver Hazard Perry on Gibraltar Island. *Photo by William G. Krejci.*

the Perry Memorial, but this was never achieved under their direction, and the original plan was soon abandoned.

By the late 1880s, the reins were taken over by a committee appointed by the association of the 7th Ohio Volunteer Infantry, and a new location for the monument was proposed. At a reunion that took place at Put-in-Bay

96

during the summer of 1887, the committee submitted a letter to Congress requesting the construction of a monument to be placed over the graves of the fallen officers from the Battle of Lake Erie. A similar letter had been previously submitted in 1883 but had little effect. Also, there was some doubt at that time as to whether the officers in question were in fact buried beneath the willow. It was agreed that this fact would be ascertained before any plans or construction commenced.

In April 1890, it was reported that the fence that enclosed the Perry Willow was falling and in a dilapidated condition. It was urged that the Perry Willow be replaced by a granite monument. That September, while plans were underway for the annual commemoration of the Battle of Lake Erie, comments were made on the appropriation of a monument to mark the burial site of the fallen officers, having long been anticipated. Until then, Congress had yet to accomplish anything in regard to carrying the plan forward.

Six years passed, and still nothing transpired. At the battle's commemoration in 1896, it was a continued hope that the burial site would have a monument built on it. Orators charged the federal government with the task of making this a reality. If the government found itself unable to do so, it was hoped that the State of Ohio would see things to fruition. Eventually, a proposal was drafted seeking appropriations from both bodies to construct and care for the monument.

The following January, further steps were taken to make that monument a reality. The cause was taken up by the Rhode Island legislation to help the plan along. A proposal was to be made before Congress by representatives from both Ohio and Rhode Island. The answer that they received wasn't quite what they had originally planned.

That spring, an old scow was towed in from Cleveland carrying a cargo of eight cannons. These, it was proposed, would encircle the aging willow tree that marked the grave of the fallen officers. The eight-inch bore cannons, dating to 1865, were sent to Put-in-Bay from the Brooklyn Navy Yard. Upon arrival, they were unceremoniously pushed from the scow onto the little beach in front of the willow, and there they remained. It turned out that the Village of Put-in-Bay didn't have the funds necessary to cover the cost of moving them from the beach to their intended position. Not long after, two men from the Ohio Historical Society proposed to have that body cover the cost of positioning the cannons as they were intended. Furthermore, they wished to replace the willow with a stone monument bearing the names of the fallen officers, their date of death and the commands to which they belonged. This never came to pass either.

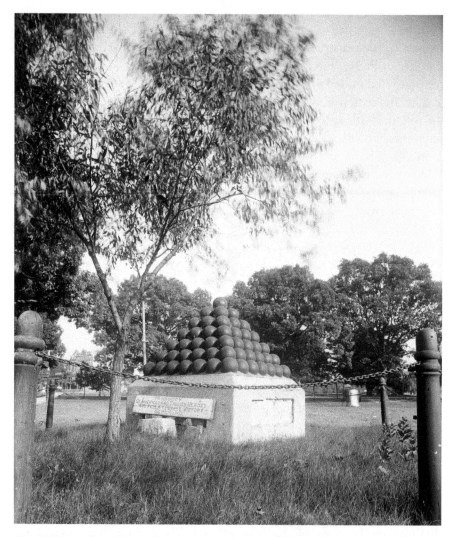

The burial site of the fallen officers from the Battle of Lake Erie, circa 1900. *Library of Congress.*

Through fundraising in 1899, the Village of Put-in-Bay secured the money needed to have the cannons placed, but not around the willow as was originally planned. Instead, these were mounted on stone bases along the north side of DeRivera Park, aimed out into the bay, where they remain to this day.

On April 17, 1900, the eighty-seven-year-old Perry Willow, which was suffering from rotted limbs and a decaying base, finally gave up the ghost

when it fell on its own accord. It was reported to be a calm day without the slightest hint of a breeze. That July, a pyramid, surrounded by eighty-five cannonballs atop a square concrete base, was placed at the burial site of the fallen officers. It was enclosed by the twelve wooden posts and chain that previously encircled the Perry Willow. Like the cannons that were sent to the island, the cannonballs used in this memorial were supplied by the naval yard in Brooklyn, New York.

In the decade that followed, the construction of a monument to Perry was more and more becoming a reality. Ultimately, a site was selected on the unused, swampy isthmus that connected East Point to the main part of the island. Today, the Perry Memorial that was built on that site exists as Perry's Victory and International Peace Memorial. Honoring Perry's victory at the Battle of Lake Erie and the subsequent peace that came out of the end of the War of 1812, it stands as the third-tallest monument in the National Park system.

The cannonball monument that was put up in DeRivera Park remained until the late summer of 1913. It was then dismantled and the ground beneath it excavated. What could be found of the remains of the six officers were exhumed and transported to the Perry Memorial, which was still under construction at that time. The officers' remains were laid to rest beneath the floor of the memorial's rotunda, where they take their repose to this day. The monument of cannonballs in DeRivera Park was rebuilt and can easily be found near the northwest corner of the park.

In the 1920s, Gibraltar Island was sold to The Ohio State University, and Franz Theodore Stone Laboratory was built on the western end of the small isle. Cooke's Castle still stands at the east end, as do the two cornerstones to the Perry memorials that never were.

THE DIVING HORSES

Yes, believe it or not, this was a real thing. There once was a time when throngs of people actually gathered to watch a horse ascend a ramp to a platform, sometimes as high as fifty or sixty feet. From there, the horse made its way out to the end of the platform and plummeted into a body of water—sometimes a lake, sometimes a pool.

It's been claimed that the idea of exhibiting a diving horse was concocted in Atlantic City in 1885 by a man named Dr. Carver, who had previously

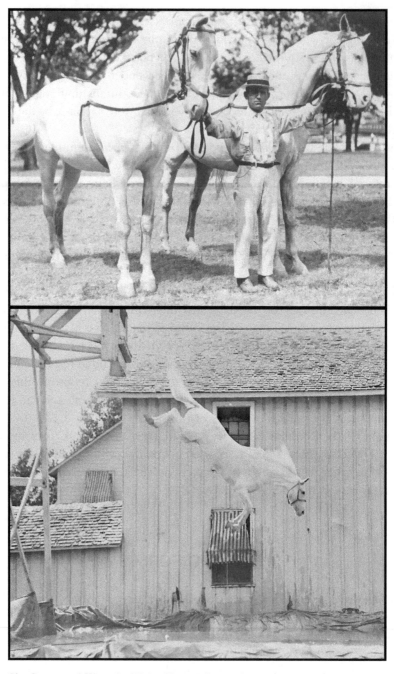

Top: Queen and King, the Diving Horses. *Bottom*: Queen takes a daring plunge. Photos circa 1920s. *Courtesy of the Lake Erie Islands Historical Society Museum.*

performed for Buffalo Bill's Wild West Show. It really isn't clear who came up with this one, but by 1896, Dr. Carver certainly was gaining notoriety in that arena.

It wasn't long before the trend caught on. By 1897, Euclid Beach Park on Cleveland's East Side boasted a pair of high diving horses named Powder Face and Cupid. Exhibitions were free to attend, as they were a draw to other, paid attractions.

Put-in-Bay certainly didn't want to be left out of the craze. Two diving horses named Queen and King were brought in for afternoon performances. These were put on in an area behind the Round House and Park Hotel. The horse ascended a ramp and jumped into a large pool of water. In later years, a house was built on the site of the pool, but it was later moved to another location.

On July 20, 1915, the horses were named as a major attraction at the annual regatta. Other attractions were a carnival, a sea circus and a parade.

In 1901, the Cincinnati Zoo also claimed to have two diving horses named King and Queen. Two years later, Fairview Park in Indianapolis boasted a pair of diving horses of the same name. It's possible that these were the same horses that performed at Put-in-Bay.

Exhibiting diving horses on the island seems to have been a relatively short affair, not running beyond the 1920s. Good thing too. The ASPCA would have a field day with this one.

THE WATER TOBOGGAN AND CHUTES AT DEISLER'S BEACH

One of the most popular attractions on the island in its early days of glory was Deisler's Beach. Being situated at one of the only sandy beaches on the island, its biggest draws were the water toboggan and chutes. Claimed as one of the safest places to swim, it boasted an abundance of lifeguards and lifesaving boats. The entire affair was owned and operated by Louis and Emma Deisler.

Louis Deisler was born in Columbus, Ohio, on April 22, 1854, to parents Michael and Barbara Deisler. In 1876, he joined the Sells Brothers Circus of Columbus and traveled with that outfit for a number of years. He was married to Emma Buchmiller on November 10, 1886, in Auglaize County, Ohio. Emma was born in Chillicothe, Ross County, Ohio, on January 7,

1864, to parents Jacob and Mary Buchmiller. At the age of sixteen, she went to work as a domestic servant in the home of a hardware merchant named Mathias Lewis in Chillicothe.

Two years after Louis and Emma were wed, they established a bathhouse at Put-in-Bay. Containing only six changing rooms, the bathhouse was located on a leased beach near one operated by Andrew Hunker, owner of the nearby Hunker House Hotel.

Around 1890, the Deislers built their first water toboggan. The entire structure rose sixteen feet above the water and featured a diving platform. The toboggan slide attached to this was forty-eight feet in length and was covered with oilcloth canvas. It was later covered with copper, which added durability to the run. Near the bathhouse, cabinet photographs depicting the lake, beach and slide were available for purchase from Detroit photographer S.S. Morrell.

The following year, Oscar Hertlein assembled a similar water toboggan at neighboring Hunker's Beach to compete with the one at Deisler's. That toboggan slide was erected a year earlier at Cedar Point. It was designed by the patent holder, Andrew J. Wegman, of Rochester, New York, and was built by carpenter August Fettel. It stood on a platform 30 feet high and had a run of 104 feet. Before arriving at Put-in-Bay, it spent the winter in downtown Sandusky, where it was used for winter sports.

Not to be outdone, the Deislers built a new toboggan chute with rollers in 1892. They also added a springboard for diving. At this, the original toboggan chute was converted into a water slide. Added to the beach area were a teeter-totter and a mammoth anchored cork for people to swim to. A new pavilion, with three hundred yards of canvas awnings, was also built along the beachfront, as was a boardwalk that extended from shore out to the toboggan rig.

In 1894, the schooner *Red Cloud*, under the command of Captain Chapman, delivered a steam engine to Put-in-Bay. This was installed on the toboggan slide rig. The steam engine powered a pump, heated water and sent that water down the slide. It also supplied power to a winch that operated a trolley on a cable. The trolley was used to return the toboggans from the lake to the top of the rig.

Finally, in 1899, Louis and Emma Deisler purchased the neighboring beach from Andrew Hunker and merged the operations into one grand beachfront attraction. Visitors came from all around to dare themselves to "Shoot the Chutes" at Deisler's Beach, either by going down the famed water toboggan or by chancing a slide down the water flume. Many gathered on

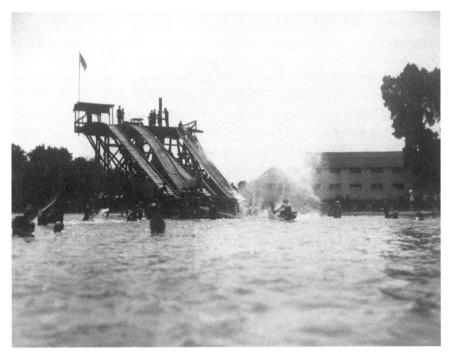

An undated photo of the water toboggan and chutes at Deisler's Beach. *Courtesy of the Lake Erie Islands Historical Society Museum.*

land to simply watch the people at the beach and slides enjoying themselves. Aside from the chutes and teeter-totter, a merry-go-round was also placed out in the three-foot-deep water.

In June 1902, considerable damage was done to the beach and toboggan rig due to extremely high water levels. Part of the wooden boardwalk was washed away. Repairs were made, and the attraction was reopened later that season.

For the summer of 1908, a new bathhouse was put up at Deisler's Beach. It ultimately had 350 changing rooms and upward of 8,500 bathing suits available for swimmers. An adjoining pavilion contained a bowling alley and concession stand. Also that season, the water toboggan was rebuilt and enlarged. Three years later, the bathhouse complex was enlarged yet again.

It should be noted that the Deislers ran a dry establishment and that Louis Deisler was a supporter of the prohibition of alcohol. At one point, the liquor license commission attempted to limit the number of saloons at Put-in-Bay to just one. This was part of a new law that proportionately matched the number of such establishments to reflect the town's population. The law was ruled

unconstitutional, but Deisler fought to keep it in place for Put-in-Bay. It wasn't so much that he was a temperate man but more of a believer in the idea that dry places, in the long run, drew bigger crowds. The law was overturned, and the island went back to operating six saloons, but within a few years, all saloons closed due to the enactment of the Eighteenth Amendment.

Emma Deisler passed away from heart trouble on January 16, 1916, in Los Angeles, where she and Louis had been wintering for the previous three years. She was interred at Green Lawn Cemetery in Columbus.

Within a couple of years of Emma's death, Louis Deisler sold the beach complex to his brother, John, and moved to Los Angeles permanently. It was there that he was married to his second wife, Margaret Allen. Louis Deisler died in Los Angeles in 1934.

Shortly before John Deisler passed in 1927, he sold the beach, toboggan rig and chutes to the Put-in-Bay Resort Company, which closed the operation in the 1930s.

THE AMUSEMENT PARK

While not established as a named amusement park, the island had a general amusement area where a number of rides were located. For many years, the site was home of Casper Schraidt's Winery.

Johann Casper Schraidt was born on March 26, 1823, in Langendiebach, Germany, to parents Casper and Elizabeth Wolf Schraidt. He was first married to Dorothea Humbert on May 7, 1852, in Frankfurt, Germany. Soon after their wedding, he and his wife immigrated to the United States and settled on South Bass Island in the early 1860s. Casper Schraidt first maintained a vineyard on East Point but purchased an eighteen-acre tract from Lorenzo B. Anthony in 1864. He set up a new vineyard and a public weingarten for visitors to the island.

Dorothea Schraidt passed away on September 16, 1881, and was buried at Crown Hill Cemetery. The following May, Casper was married to Wilhelmina Trapp. Wilhelmina was born on October 28, 1854, in Sandusky to parents Alois and Stephanie Trapp. Sadly, the marriage between Casper and Wilhelmina was brief, as Casper Schraidt died at Put-in-Bay on August 1, 1886.

Wilhelmina Schraidt remained a widow for only three years. She was married to William Wigand on November 26, 1889. William was born on August 9, 1862, in Sandusky, Ohio, to parents Conrad and Martha Wigand.

He first came to the island in the 1870s to live with his brother John, who operated a restaurant. Like Wilhelmina's first husband, William's time with her was brief. He died suddenly on February 22, 1892, at the age of twenty-nine.

Wilhelmina Wigand continued to operate the winery well into the twentieth century. She and her staff also maintained a dancing pavilion, where wine was available for purchase.

In early September 1902, it was announced that Frederick Ingersoll would build what was termed a "Roller Toboggan" or "Figure Eight" at Put-in-Bay. This would be similar to a roller coaster called the Loop that he had built at Cedar Point earlier that year. Construction on the new coaster started on September 15, 1902.

Frederick Ingersoll hailed from New Jersey. At an early age, he invented a number of coin-operated amusements. Before long, he was developing grander entertainments. By the late 1890s, he had established the Ingersoll Construction Company and was actively engaged in the design and building of roller coasters, particularly figure-eight coasters, also popularly called "Loop the Loops," which he'd invented.

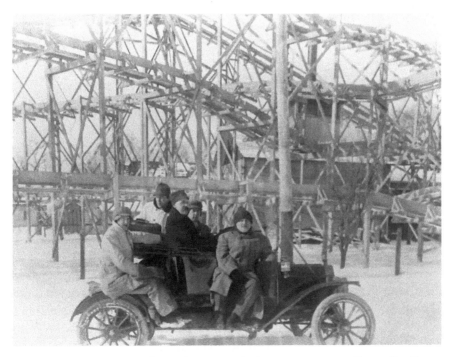

Men posing in front of one of the roller coasters in the amusement area. *Courtesy Dan Savage.*

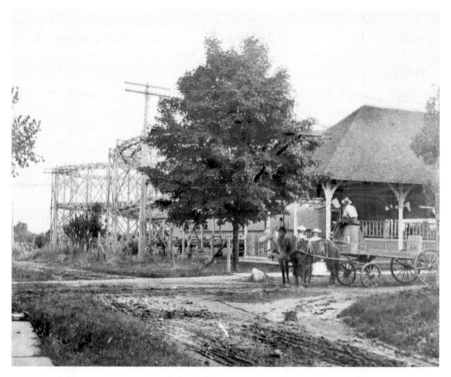

The Aerial Rail Way was one of two roller coasters that were on hand. *Courtesy Phillip Boyles.*

Aside from the coaster at Cedar Point, he had also installed there a merry-go-round and a laughing gallery, which was an early form of a fun house. In 1905, Ingersoll opened the world's first chain of amusement parks under the name Luna Park. In all, Frederick Ingersoll designed and built some 277 roller coasters, and the one at Put-in-Bay was one of those. That first roller coaster was operated by Cleve Pomeroy of Cleveland, who returned to the island each summer. In later years, the name "Aerial Rail Way" was applied to that coaster.

A second roller coaster, commonly referred to as "Dip the Dips" or a "Scenic Railroad Coaster," was built around 1912. This was located along the western edge of the amusement area. Among the other rides found there was a "Circle Swing" and a carousel. The carousel in question was built by the Armitage & Herschell Company of North Tonawanda, New York. That company had been founded by Allan Herschell and James Armitage in 1873 and remained in operation under that name until 1901, at which time Herschell sold his interests to Eugene de Kleist, who operated a nearby

band organ company. That organ company soon after merged with one operated by Rudolph Wurlitzer and became the Wurlitzer Organ Company. Within a couple of years of ending his partnership with Armitage, Herschell opened a new company with his in-laws, the Spillmans, under the name Herschell Spillman Company. In 1915, he parted ways with the Spillmans and established the Allan Herschell Company.

Many more carousels would grace the island in later years. Of an interesting note, Kimberly's Carousel, which today fronts the north side of where this park once stood, was also built by the Allan Herschell Company of North Tonawanda. Dating to 1917, the carousel was brought to the island by George and June Stoiber in 1979 and was named for their daughter. The upper panels feature scenes from the island, and the menagerie of carved wooden animals includes the only yellow perch carousel animal in existence. Like most Herschell carousels, the music is provided by a Wurlitzer band organ.

The Carriage House, located immediately to the east of Kimberly's Carousel, also fronted the amusement park. It was built in 1917 and replaced the former wine house for the winery.

Following the Stock Market Crash of 1929 and the Great Depression that followed, the amusement park, rides and winery were torn down, and the site was turned into a golf course. The location of that first Aerial Rail

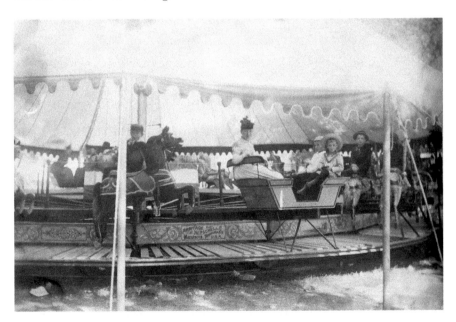

A family takes a spin on the Armitage and Herschell Carousel. *Courtesy Phillip Boyles.*

Way coaster is now the Downtown Bus Station and depot for the Put-in-Bay Tour Train.

Wigand's Dancing Pavilion is now occupied by the parking lot behind the Candy Bar. The second coaster was located directly behind this, ran south across the middle of McCann Field and continued almost as far as the present site of the Sand Bar and Adventure Bay.

THE OBSERVATION PLATFORM

More than twenty years before the construction of Perry's Victory and International Peace Memorial, visitors to Put-in-Bay were afforded a spectacular bird's-eye-view of the island. This was by means of a tall tower that was erected at the east end of DeRivera Park.

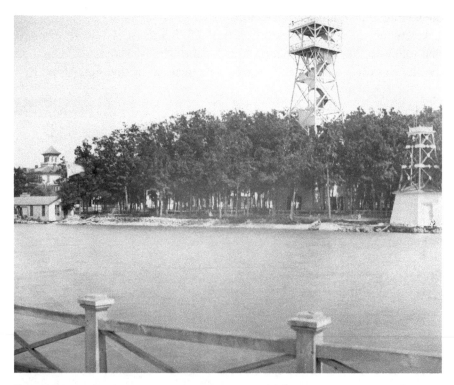

The old Observation Platform in DeRivera Park, circa 1890. *Courtesy Rutherford B. Hayes Presidential Library & Museums, Charles E. Frohman Collection.*

This frame structure was built in the summer of 1890. The land it was erected on was the two-acre parcel that was originally left off Joseph de Rivera's tract that he deeded to the Village of Put-in-Bay, which later became DeRivera Park.

In all, the tower stood more than eighty feet tall. At the top, it had two separate platforms for viewing that offered a commanding panorama of the area. At its base was an enclosed saloon that was almost as popular as the lookout at the top.

In 1895, the two-acre lot was purchased by Thomas Webb and William Stimmel, who proceeded to build the Rivera Party Rooms on the waterfront. The Observation Tower remained a popular attraction through 1899. That year, the Village of Put-in-Bay seized the property through eminent domain and annexed it to DeRivera Park. At this, the Rivera Party Rooms were moved to Perry's Cave, and the Observation Platform was dismantled.

Today, the site of this tower is occupied by the swing sets just to the north of the public restrooms in DeRivera Park.

THE NEEDLE'S EYE

One of the most recently lost attractions at Put-in-Bay is what was popularly known as the Needle's Eye. This was a natural stone arch that protruded from the northeast side of Gibraltar Island. It extended over a small watery passage, creating a keyhole between Gibraltar and a pillar of rock.

Gibraltar Island was said to have been named by Commodore Robert Heriot Barclay, commander of the British squadron, upon being brought to Put-in-Bay after his defeat at the Battle of Lake Erie. Eight years earlier, Barclay had fought at the Battle of Trafalgar and, soon after, passed the Rock of Gibraltar. He saw similarities in shape, if not in size, between that rock feature and the small island in the bay. It's said that Perry dubbed the little island Gibraltar in honor of Barclay's observance.

Located above and slightly to the south of the Needle's Eye is the site called Perry's Lookout, where it was said that the distant British squadron was sighted on the morning of the Battle of Lake Erie. In fact, the masthead lookout aboard the U.S. brig *Lawrence* had sighted the British sails, yet it's known that Perry kept a detachment of men on Gibraltar for that purpose. It appears that the site was later used for another purpose. That story is presented in the next chapter.

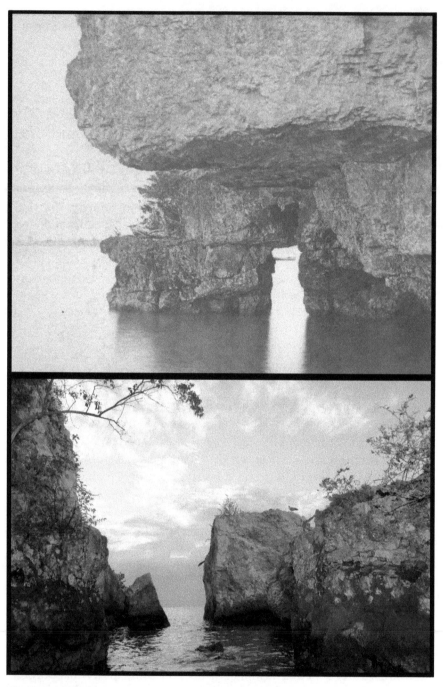

Top: Historic view of the Needle's Eye on Gibraltar Island. *Wikimedia Commons*. *Bottom*: Ruins of the Needle's Eye after the collapse. *Courtesy Autumn Therese Taylor.*

For many years, the Needle's Eye was a popular subject for photographers and often enough found its way onto postcards. In recent decades, passing through the Needle's Eye was a popular activity for kayakers. Too narrow for rowboats, the passage was just wide enough to admit a kayak.

Worn down by two years of record high water levels on Lake Erie, the Needle's Eye finally gave in to the elements and collapsed into the lake in early March 2020. The original passage still exists but no longer has the natural stone archway above it. The channel is now formed by Gibraltar and two large rocks that formally composed the roof and pillar. An appropriate name for these would be the Needle's Islands.

Chapter 5

VILLAGE SITES

SHADOWS OF THE PAST

Back in the village, traces of history are all around, though places like Fox's Dock and the Colonial exist now only in memory. Beyond these, the village holds many other hidden secrets. Some are in plain view. Some, with a deep storied past, lie buried beneath our feet.

THE BLOCKHOUSE

In June 1881, the *Western Magazine*, an illustrated literary monthly, featured a story called "Our Excursion to the Lakes." The tale was penned by a man named W.D. Boyce. For all intents and purposes, it appears to be a fictional account of a man from St. Louis who is invited by his sister and her husband to join them on a trip to Lake Erie. Accompanying them on this voyage are his brother-in-law's sister and a professor friend of hers, who becomes her romantic interest. While the story and characters seem to be fabricated, the many locations visited along the way by this party of vacationers are very real and accurately described. It's the last stop on the journey that many will find of interest.

Arriving at Put-in-Bay, the excursionists get caught up in the enjoyments of the island, taking in evening strolls and drives or enjoying a dance at

Illustration of the blockhouse in Boyce's story of Put-in-Bay. *From* The Western Magazine, *June 1881.*

one of the many hotel parlors. The narrator describes the island quite well, with its vineyards and hotels, and even remarks on Jay Cooke's fine villa on nearby Gibraltar Island. At one point, the storyteller makes mention of his discovery of an old blockhouse standing on a high, rocky point in a quiet and unfrequented part of the bay. This was accessible only by a rocky, winding road. The blockhouse in question is an essential setting for the story being relayed, as this is where a romance unfolds.

Interestingly, such a place actually existed.

Following the Battle of Lake Erie, the U.S. squadron returned to Put-in-Bay with the captured British and their six vessels, which had been taken as prizes. Two days following the battle, the fallen officers were laid to rest together in one grave near the verge of the bay. That evening, a strong gale blew through and severely damaged the captured British ships *Queen Charlotte* and *Detroit*, with both vessels losing their masts. Major repairs would be needed if they were to be in any condition to sail back to Erie, Pennsylvania, but time was against them.

In the days that followed, Commodore Perry and his men concentrated on transporting General William Henry Harrison and his Army of the Northwest across the lake, where they were landed on the Canadian shore late that September. A few weeks later, Harrison's army overtook and defeated the British forces at Moraviantown.

Back at Put-in-Bay, the Lake Erie squadron made ready to return to its regular station at Erie. With the end of the sailing season drawing near, it was realized that the *Queen Charlotte* and *Detroit* were in no condition to make the journey. Preparations were made for the two prize ships to be left in the harbor of the desolated island for the winter.

Upon their arrival at Erie, Commodore Perry returned to the East, and Jesse Duncan Elliott, who had been second in command at the Battle of Lake Erie, assumed command of the Erie Station.

Not all vessels in the squadron returned immediately to Pennsylvania. The schooners *Somers* and *Ohio* spent the later part of the fall transporting supplies from Cleveland to Detroit. Once they'd completed their assignment, they settled in at Put-in-Bay to watch over the *Queen Charlotte* and *Detroit*.

Realizing that better defenses were needed, Sailing Master Stephen Champlin was ordered by Commodore Elliott on December 15 to take the U.S. schooner *Tigress* and return with a detachment of men to Put-in-Bay. In these orders, Elliott recommended that a part of Champlin's force be stationed in a blockhouse.

The next day, Champlin set out with Lieutenant John Packett, Dr. Nathaniel Eastman, Sailing Master Robert Smith Tatem and eighteen seamen and arrived at Put-in-Bay on Christmas Day 1813. Upon reaching the island, the *Tigress* and *Ohio* returned to Erie with Packett and Tatem, while the *Somers* remained. Champlain immediately assumed command of the prize vessels and all matters relating to the operations at Put-in-Bay. Per Elliott's orders, he at once set men to the task of building up the defenses, erecting a blockhouse and making the cannons ready, should the British attempt to cross the lake, attack the island and reclaim or destroy the captured ships in the harbor.

It wasn't long before Champlin had things well in hand. He dispatched a letter to Commodore Elliott at Erie that read:

> *Put-in-Bay January 14, 1814*
> *Sir: I have everything in complete order at this place. I have the guns mounted in the block-house. I have mounted on board the* Detroit *21 guns, and on board the* Queen Charlotte *19. I have mounted those 32-pounders and 24-pounders that were left on board the* Detroit. *I can bring 12 guns to bear in every direction. The ice is constantly kept open. I think if they attack us they will meet with a pretty warm reception. The sailors are all well, the soldiers very sick. We have provisions enough to last till the first of April. The beef is very bad.*
>
> *I have the honor to be your ob'dt servant*
> *Stephen Champlin*

Three days later, Major General John Stites Gano of the Ohio Militia penned a letter to General William Henry Harrison that considered the situation at Put-in-Bay. The letter, in part, read thus:

The disagreeable news from below occasions me to have great anxiety for the vessels at Put-in-Bay. I proceeded a few days ago to Portage, in order to cross to see their situation; the ice prevented my going by water and was not sufficient to bear. I have, however, been relieved by a visit from Lieutenant Champlin, and Doctor Eastman of the navy, who came up the night before last and returned yesterday; they came over on the ice, though it was very thin in places. The lieutenant informs me he has ten seamen and forty soldiers, and has his vessels and guns so prepared, that, in case of an attack, he can bring about forty to bear from on board and a small block-house, on the rocky point of land near the vessels.

Commodore Elliott's fears of an attack at Put-in-Bay were well founded. At that same time, the British were contemplating the possibility of a full-on assault of the island, though there were many challenges preventing this from happening. First, the blockhouse had proved a strong deterrent. Also, the lack of a solid and reliable ice formation on the lake made it nearly impossible to cross at any great distance. On February 14, 1814, Lieutenant General Gordon Drummond sent a letter to Noah Freer, military secretary in Quebec, an excerpt of which stated:

I have this day received information from a respectable person, who had been specially employed in collecting intelligence in the neighbourhood of Presque Isle, &c. He says, there are six large and three small vessels at that place, and that their two largest are at Put in Bay; where a Block house has been erected for their defense.

Five days later, Drummond sent a letter to Sir George Prevost, governor-in-chief of British North America, that further compounded these concerns:

The observations contained in Your Excellency's letter of the 29th Ultimo have been realized. And I have been most fully and most amply justified in the reluctant decision, I made, at that time, by the present state of the weather. For the last four days past, the thaw has been so considerable, that many of the oldest inhabitants of this Province, which at all times defers so much in its climate from the lower one, are almost induced to believe, that, even at this Early period, the winter is fast breaking up. The snow has been hitherto but very thin upon the ground; and the bordage upon Lake Erie never so strong or sound as to render a passage upon it to Put-in-Bay sufficiently safe.

I, therefore, do not hesitate in declaring to Your Excellency, that any attempt against The Enemy's vessels upon Lake Erie, or their Force at Detroit, is, at present totally impracticable, as well from the unusual mildness of the weather as from the lateness of the season.

In late January 1814, Commodore Elliott sent a reinforcement of men from Erie, under the command of Lieutenant John Packett, by land to Sandusky, where they were to cross the ice to Put-in-Bay and join up with Stephen Champlin's forces. It was anticipated that the British could strike at any moment, and a strengthened garrison was believed to be more effective against such a force. The additional men being sent were drawn from the army by General Cass.

Upon reaching Sandusky, Lieutenant Packett found much difficulty in crossing the ice to Put-in-Bay. His detachment finally arrived in late February. Upon his arrival, Packett handed Champlin a letter from Commodore Elliott that had been written back on January 9, which in part read:

In addition to your last instructions, I have the honor to pass you a second one. That is, you will have the ice cut from around the two ships, and the pivot guns on board each ship always kept clear, and ready for action, and that you will be particularly guarded, and not suffer yourself to be surprised night or day. It is more than probable that an attack will be made as soon as the ice makes, and the enemy may have a hope of succeeding by attacking you by night, you are not to retreat nor surrender as long as your men and ammunition will one remain for the other. I would advise you to be particular how you admit idle visitors. Spies can come under that cloak. Lieut. Packett will leave with you two hundred men, in addition to your present number which will make your defenses a force for Gibraltar. You will keep me constantly advised as to your situation.

The rest of the winter wore on hard. Hunger and cold swept the island, bringing with them illness and death. The anticipated attack from the British never transpired.

That April, with the lake completely open and free of ice, Captain Daniel Dobbins returned to Put-in-Bay with the schooner *Ohio*, bringing with him much-needed stores and supplies. He assisted in fitting out the *Queen Charlotte* and *Detroit* and helped bring them back to Erie, where they arrived on May 1, 1814. The soldiers from the army who had been stationed at Put-in-Bay

to aid in the defenses were recalled to Detroit. At this, the Put-in-Bay Station and blockhouse were abandoned.

The question now begs to be asked: where was this blockhouse situated?

Stephen Champlin wrote to Commodore Elliott simply stating that the blockhouse had guns mounted in it. There's also a brief mention of it in a book on the life of Napoleon Bonaparte that talks of foreign military defenses, stating, "The Americans have also a strong battery and a block-house at the mouth of another harbour, named Put-in-Bay." Meanwhile, Major General John Gano wrote to General Harrison claiming that the blockhouse was on a rocky point of land near the vessels. This might suggest that it was on a point of land on South Bass Island itself. If that were the case, the best candidate for a defensive point to protect the harbor would be Peach Point.

In W.D. Boyce's 1881 story, "Our Excursion to the Lakes," he describes the blockhouse as being on a high, rocky point in a quiet and unfrequented part of the bay, accessible by a rocky, winding road. This also seems to fit with an early description of Peach Point. The other locations described by Boyce in his story are very real places, and the illustrations that accompany them are incredibly accurate. It's curious that the blockhouse, and the illustration of it, would be invented while the others were not. There's no mention of a blockhouse in any account by early island settlers, which suggests that it no longer existed during their time, let alone in the early 1880s. It's most likely that Boyce had heard of a blockhouse once existing at Put-in-Bay and simply reimagined it for his story.

The best clue to its location was given in Commodore Elliott's letter to Stephen Champlin that was penned on January 9, 1814. This appears in his mention of "a force for Gibraltar." That location was confirmed in an account written in September 1858 by Quintus Flaminius Atkins, who formerly was a lieutenant in the 19th U.S. Infantry. Atkins's account firmly asserted that the blockhouse was located on Gibraltar Island.

When Harrison and his men were transported to the Canadian shore in the days following the Battle of Lake Erie, around three hundred were unfit for duty. Those men were left behind at South Bass Island, under Lieutenant Atkins's charge, but most were ultimately conveyed back to Detroit. By late fall, only fifty-two men from the army remained at Put-in-Bay. These men were quartered by Atkins aboard the two prize vessels in the harbor. Also, four men from the navy remained to keep charge of the prizes. Midshipman John Berrien Montgomery was in command of the *Queen Charlotte* and was assisted by a seaman named Brown. The *Detroit* was under the command

Perry's Lookout on Gibraltar Island. *Photo by William G. Krejci.*

of Midshipman Samuel W. Adams. Assisting him was a gunner who was known to the men as Long Tom. Atkins remembered Champlin's arrival on Christmas Day 1813.

Atkins claimed that he and his men cleared the land on Gibraltar and commenced construction of the blockhouse, which measured sixteen feet square on the lower level and twenty feet square, by six feet high, on the upper story. The walls and floors were of hewn timbers, and each side of the upper floor had one porthole from which a four- or six-pounder cannon could be fired. The cannons had been pulled from the prize vessels and mounted on ships' carriages with truck wheels.

Lieutenant Atkins's statement is reinforced by an article that appeared in the *Sandusky Register* on August 19, 1892. The article began by saying that there were a few people still living at Put-in-Bay who remembered seeing the remains of an old scaffold, capping a wall of rugged and precipitous rock, near what is known as Needle's Eye on Gibraltar Island. Also remembered by early pioneers was a grass-grown but visibly outlined path leading from that point to the opposite side of the island. The scaffolding had long since disappeared, but the spot on which it stood had since been referred to as Perry's Lookout, and it is still to this day.

Of an interesting side note, it turns out that W.D. Boyce, who authored the story for the *Western Magazine*, is none other than William Dickson Boyce, founder of the Boy Scouts of America. Boyce spent years as a travel writer and later became a publisher. "Our Excursion to the Lakes" is a previously unattributed article that he wrote while a student at the College of Wooster. Having been released in 1881, this also makes it his first published work.

FIRST STATE FISH HATCHERY

Aside from being a Mecca for vacationers, the Lake Erie Islands region is famously known for its excellent fishing. It's not uncommon for anglers to reach their maximum limit of fish a short time after casting their lines. There was, however, a time when no such regulations were in place. Needless to say, this caused great harm to the lake, and an answer was sought.

Relaxed laws on gill and trap nets, commercial fishing operations and leisure angling put a strain on the lake's natural resources. It was obvious that clear action was needed. By 1875, the state was operating hatcheries throughout the area on the adjacent waters of Lake Erie, but a central facility close to the bulk of the commercial fishing operations was in demand. The U.S. government took the first steps.

In 1889, the U.S. Bureau of Fisheries purchased one acre of land on Peach Point from the Forest City Ice Company, which operated a massive icehouse on site. Construction on the U.S. hatchery started that fall a short distance to the south of the icehouse. The cost of the facility was $20,000. The following summer, the hatchery was in full operation, with former state senator John Jay Stranahan as superintendent.

In 1907, the State Fish and Game Commission purchased the land immediately to the north of the federal facility to build a hatchery that would be operated by the State of Ohio. That March, the commission received bids for construction, which was estimated to cost around $8,000. The state had previously operated a facility at Lakeside but, owing to poor water quality near the Marblehead Peninsula, decided to close that operation and move to Put-in-Bay.

The contract for building the new hatchery was awarded in early April to John Feick of Sandusky, who bid the job at $8,069. The new two-story frame structure was built between the federal facility and the icehouse for

the Forest City Ice Company. It began operation late that fall by raising a brood of whitefish.

The federal hatchery primarily dealt in the propagating of pickerel, while the state facility focused on pike and herring. Within a few years, they had expanded into breeding perch and bass.

In the early morning hours of Sunday, May 31, 1914, a fire broke out in the carpenter's shop, where a number of men had been working the night before. By the time the fire was discovered, the flames had gained such headway that the fire department was unable to control the blaze. Before long, the entire building was engulfed. The facility, which was a total loss, was insured for $10,000, but damage estimates were placed closer to $20,000.

The federal facility next door was spared any damage, primarily owing to a strong south wind. Fortunate also was the fact that the fish being raised at the state facility, numbering in the tens of thousands, had been removed just a few days earlier.

By early July, plans for a new state hatchery were approved by the agricultural commission. The new structure was estimated to cost $15,000 and would be, by the standards of the day, fireproof. By June of the following year, a new temporary hatchery was operational. In 1919, the hatchery was

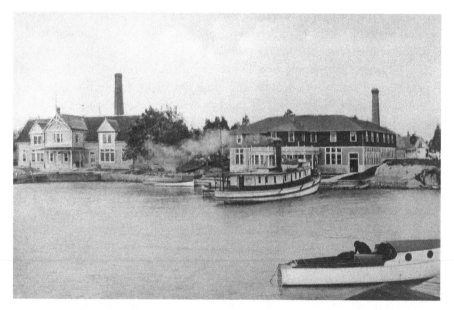

Hatcheries at Put-in-Bay. The first state fish hatchery sits on the right. *Courtesy Dan Savage and the Lake Erie Islands Historical Society Museum.*

enlarged, modified and rebuilt into a brick structure. Like the first hatchery, the second building was erected by Feick and Sons. It raised a wide range of species, including salmon and steelhead trout.

The nearby federal facility was sold to the State of Ohio in 1940 and is today used by Stone Lab. The second state fish hatchery building closed in 1988 and was converted into a visitors' center by the Ohio Department of Natural Resources in 1992. In 2009, the Ohio Sea Grant took over management. It now operates at the Aquatic Visitors' Center in conjunction with nearby Stone Lab on Gibraltar Island. Here, visitors can learn about the original operations of the hatchery and explore the native and invasive species that are found in the lake. Children are also welcome to try their hand at fishing for free from the adjacent pier.

FOX'S DOCK

One of the most popular steamboat landings at Put-in-Bay was Fox's Dock. Located just to the north of the Beebe House, later the Hotel Commodore, the landing was known for its convenience and easy accessibility to nearby accommodations. In looking at its colorful history and the chain of misfortunes that befell it, one might think this dock to be jinxed. In all honesty, when you have a location that saw as much traffic as Fox's Dock, incidents are bound to occur.

This landing was originally built as Brown's Dock in 1865. That year, Lemuel Storrs Brown arrived at Put-in-Bay. His arrival was preceded two years earlier by that of his first cousin, John Brown Jr., son of the famous abolitionist. The dock was a simple structure on pilings that jutted into the harbor. In January 1867, a considerable extension was added, giving it a greater length into the deeper waters of the bay. This accommodated larger steam vessels that had a deeper draft. By the 1870s, stone-filled cribs had been placed beneath the dock for supports, and a small freight house was built near the end.

In the summer of 1878, the dock was reported to have been purchased by the proprietors of the D&C steamboat line, which ran passenger vessels out of Cleveland, Toledo and Detroit. The name Brown's Dock remained affixed to the concern until around 1890, at which time it was taken over by Henry Fox. At this point, the dock started to be referred to as Fox's Dock.

The landing was greatly enlarged in both length and width. Like its predecessor, it was supported primarily by stone-filled cribs. It should be pointed out that this was more than just a simple wooden wharf. Many businesses operated at Fox's Dock. Wine was for sale at the ticket office that was located near the boarding area for the steamers. Beyond that and nearer to the end of the dock was a large, two-story freight house. Another two-story warehouse that contained horse stables, employee housing and offices was located near the south end of the wharf, closer to Bayview Avenue.

One of those who ran their businesses on Fox's Dock was Walter Ladd. Previously, he had operated the boathouse for the first Put-in-Bay House until that hotel burned down in 1878. The following year, he opened his own boathouse near the east end of the village park. That structure, being located on the frontage of the parcel claimed by the village in 1899, was deemed condemned by the village and torn down. Immediately after, he reestablished his boat rental business on Fox's Dock. Ladd also ran a small concession stand.

The first serious incident hit the facility on Friday, July 5, 1901, when Fox's Dock caught fire. The structure burned for about twenty minutes before the flames were brought under control. The ignition source was a disorderly visitor who had set off firecrackers under the dock. It was an extremely windy evening, and the fire spread quickly.

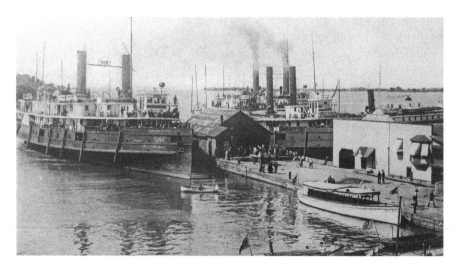

Fox's Dock, circa 1905. The steamer *City of Detroit* is on the left. *Courtesy Dan Savage.*

The new Fox's Dock Pavilion was added to the west side of the complex around 1905. This was built in the location that was previously occupied by Walter Ladd's first boathouse. It was a two-story block construction with two three-story towers at either end that resembled lighthouses. A covered outdoor patio on the west side of the pavilion offered picturesque vistas of the bay.

On June 19, 1914, the steamer *State of Ohio* crashed into Fox's Dock when it arrived with one hundred passengers from Toledo. The ship nearly cut the dock in two. There were no injuries reported on the dock or the steamer, but the commotion caused several teams of horses hitched near the dock to panic and bolt. One team collided with and destroyed a nearby pavilion.

The majority of Fox's Dock was destroyed by a fire on the night of Saturday, July 4, 1914. A fire broke out in the warehouse area at 11:15 p.m. It was believed to have been started by a careless visitor boarding a vessel who had thrown a smoldering cigar into a pile of hay near the horse stables. Many horses were killed in the blaze. Though nearly every building was lost, the pavilion survived the fire.

The fire burned through a good part of the night. At that time, several gas barrels were stored on the dock. It wasn't long before those started to explode. Moored to the dock was a scow loaded with even more gasoline tanks. In a heroic move, Walter Ladd untied the burning scow and rowed it away from the dock to a safe place farther out into the harbor, where it exploded and sank. Ladd was painfully burned about the face, arms and neck.

Between the dock being rammed by the steamer *State of Ohio* and the fire that followed two weeks later, it was proving to be an unfortunate season for the island, as the state fish hatchery on Peach Point had burned down just over a month earlier.

The Fox's Dock Pavilion was destroyed in a storm on the night of Thursday, August 2, 1934. Many of the blocks were picked up by the wind and dropped on a nearby parked car belonging to a man named Charles Mahler, destroying it entirely. The papers were reporting the storm as a cyclone that covered multiple states and ripped through the region at seventy-five miles per hour. Eight people were killed in Michigan, while another five lost their lives in Ohio. All in all, the storm did considerable damage to the area. A number of houses at Put-in-Bay had their roofs blown off, and many boats were parted from their moorings. Docks were wrecked, and the warehouse at the Doller Dock was blown into the bay. In the end, despite the lack of human casualties, Put-in-Bay was considered to be the hardest-hit location.

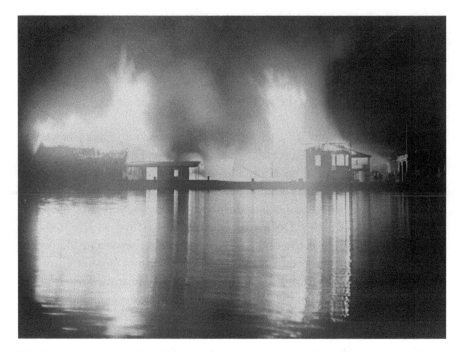

The fire that broke out at Fox's Dock on July 4, 1914. The structures burning on the left are the freight house and ticket office. The building on the right contained the livery stables, warehouse, apartments and offices. *Courtesy Dan Savage and the Lake Erie Islands Historical Society Museum.*

On a higher note, it should be said that Fox's Dock wasn't all disaster and misfortune. It also happens to be the site of a very important historic event. On August 23, 1899, a wireless telegraph message was sent from Lightship No. 70 to a receiving station at the Cliff House in San Francisco. This was the first ship-to-shore wireless transmission ever sent. However, on July 18, 1907, the first ship-to-shore *radio* broadcast took place at Put-in-Bay. Dr. Lee deForest, inventor of the vacuum tube, was positioned out in the bay with a transmitter aboard the yacht *Thelma*. Meanwhile, his assistant, Frank E. Butler, was stationed with a receiver at the Fox's Dock Pavilion. The first wireless voice radio transmission broadcast carried the results of the annual Inter-Lakes Yachting Association Regatta. It was at Fox's Dock that modern radio was born.

After the fire in 1914, a smaller dock was put up immediately to the west, and it exists in that configuration to this day. Over the next half century, it changed hands a few times. It was operated as a gas dock by Nate Ladd, whose father ran the boathouse on Fox's Dock in the early twentieth century.

The Erie Isle Ferry Company also operated out of it. For a number of years, it was operated as Parker's Dock, and today it is the island port for the Jet Express, called Duggan's Dock.

The original site of Fox's Dock is now occupied by the Keys complex. Fox's Dock Pavilion was located along the north side of Bayview Avenue where the entrance to the Jet Express landing currently sits. That location, which was also the site of the earlier Brown's Dock, is marked with an Ohio State Historical Marker for being the site of the first ship-to-shore radio broadcast.

THE MUSEUM

In looking back on the rich island history that has been shared thus far, it would stand to reason that a museum celebrating this storied past must exist somewhere. You're in luck. Put-in-Bay is home to the Lake Erie Islands Historical Society Museum, located at 443 Catawba Avenue. The organization that operates the museum was founded in 1975 as the Put-in-Bay Centennial Committee but changed its name to the Lake Erie Islands Historical Society ten years later. In 1987, it opened a small museum in the old Put-in-Bay Bottling Works building across the lot from town hall. A six-thousand-square-foot museum was opened in 1998 next to the first facility.

Visitors to the museum are directed to a small auditorium, where they're treated to a fifteen-minute video that gives a brief yet dynamic overview of the island's history. From there, visitors are invited to explore the museum at their own leisure. Comprehensive exhibits on the Hotel Victory, early island settlers, the Battle of Lake Erie, the island's winemaking heritage and the various modes of tourist transportation are displayed with great detail.

Interestingly, this was not the first museum to grace the island. It was predated by another more than one hundred years earlier. This early museum at Put-in-Bay was located on Delaware Avenue between the Hunker House Hotel and the Round House. It was opened to the public on June 26, 1874, and was owned and operated by A.B. Richmond of Meadville, Pennsylvania.

Dr. Almond Benson Richmond was born in Indiana and received his early education in that state but continued on to attend Allegheny College. He obtained a medical degree and practiced in Meadville for the next three years. In time, he developed an interest in the law and was admitted to the Crawford County Bar in 1851. Over the next two decades, he earned the

reputation of being Pennsylvania's best criminal defense attorney. Also of note was Almond Richmond's penchant for collecting oddities and curiosities.

Finding that he had a large sum of money sitting idle, he decided to open a museum at Put-in-Bay to house and share with the public the vast collection of curiosities he'd accumulated. Plans for the museum were announced in September 1873, and not long after, construction commenced on the building that would house this collection. It was a large structure that measured fifty feet in width and ninety feet deep. The front featured a protruding forty-foot-tall tower with two shorter towers flanking it. The tops of these were crowned with battlements, giving the building the appearance of a medieval castle. The two-story structure was constructed from blue sandstone and featured two tiers of galleries.

Almond Richmond made it clear from the start that in no way was he a showman of any sort, nor was his collection a professional one. It was assembled over the span of the previous thirty years simply out of a love and enthusiasm for art and nature.

It was hoped that everyone would find something of interest in this museum. More than anything, the collection was believed to be specifically appealing to the scientifically curious, as most of its contents were rarities relative to the natural world. Among the items on exhibit were countless taxidermies of animals; over one thousand stuffed and mounted birds; Asian works of art; Indian artifacts; mementos from the Battle of Lake Erie; shell, agate, mineral and fossil specimens; mastodon remains; ancient coins; and other general relics and curiosities. Located in the center of the museum was a well-stocked aquarium, measuring twenty-five feet square, that contained a wide assortment of native fish commonly found in the lake and its adjoining waterways.

One of the centerpieces of the collection was a massive and extremely well-accomplished diorama of the oil region of Venango County, Pennsylvania, which Dr. Richmond had personally built. It contained details such as men drilling, rail cars on a trestle bridge and amazing re-creations of the county's natural scenery, including the many streams and mountains that are found there.

By the following year, the museum at Put-in-Bay was being hailed as one of the finest west of New York. Admission to the museum was free, as it was hoped that the business would make money at the attached restaurant, café and saloon, which featured a piano for guests' entertainment. The saloon specialized in selling beer from the Kuebeler and Stang Brewing Company.

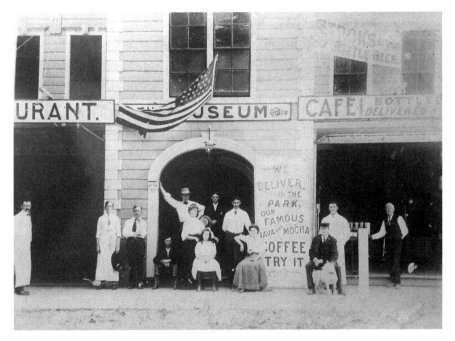

The Put-in-Bay Museum, circa 1891. *Courtesy Dan Savage.*

Bottles of Stroh's were also available. The café was known for its java and mocha coffee and also offered ice cream and tea. The restaurant sold affordable sandwiches. Both the restaurant and café offered delivery service to the park across the street. The museum also had an attached arcade that housed several stands where souvenirs of Put-in-Bay could be purchased.

While Almond Richmond owned the museum, management was largely overseen by brothers Christian and Louis Engel. By 1899, Thomas McLaughlin had taken over operations. Control of the affair was overseen by James B. Ward, proprietor of the Ward House, formerly the Hunker House Hotel, which was located on the lot immediately to the east. Through this era, the museum was referred to as Ward's Museum. A man named Ike Weiler of Sandusky was operating the café.

Unfortunately, the museum also hosted cockfighting during that time, which came to an end around 1900. The sport was dropped on account of it causing disagreements and heavy rivalries among the islanders. Sadly, the discontinuation had nothing to do with the welfare of the birds themselves.

By 1903, the property still appeared on maps as being in the Richmond family, but records showed it being owned by Almond's son Hiram Morris Richmond. Interestingly, Hiram had died in early 1884.

Almond Richmond died in Meadville on July 18, 1906. Soon after, the property passed into the hands of the firm Lauber Bros. That firm was established by Theodore and Albert Lauber, who operated a saloon in Sandusky. A few years into their partnership, Albert left the firm, and the named was changed to Lauber and Co.

Not long after Lauber Bros. purchased the property, the building was leased to a twenty-one-year-old news dealer from Port Clinton named Charles S. Stensen. In 1908, Stensen transferred his lease to Lucas Meyer and T.B. Alexander, who was now operating the former Hunker House and Ward's House as the Crescent Hotel. In the summer of 1911, the partnership of Gibson & Ehlers of Put-in-Bay took over the lease. They remodeled and refurnished the building that formerly housed the old museum and attempted to turn it into a dining establishment, which didn't succeed.

That November, Charles Stensen resumed the lease on the building and operated it through the centennial celebrations of the Battle of Lake Erie in September 1913. After his lease expired, Stensen stayed on at Put-in-Bay for a number of years and, following the death of T.B. Alexander, became proprietor of the Crescent Hotel.

In 1914, James A. Poulos came to Put-in-Bay and took over the old museum building, where he opened a burger stand. Not long after, he demolished the old museum and put up a new structure on the site that he operated as the Put-in-Bay Cafeteria. In 1935, he changed the name to Jim's Place and added a bar to the establishment. Poulos served as mayor of Put-in-Bay in the 1960s.

Jim's Place ultimately became Walt's Restaurant, later the Wheel House. That was torn down in the 1970s and was replaced with Misty Bay Boutique and the Shirt Shack. The site of the old Put-in-Bay Museum is now occupied by the Shirt Shack.

THE COLONIAL

Of all the buildings to grace the island throughout the years, few are as recognizable as the famed Colonial. For eighty-two years, this iconic structure welcomed guests and hosted countless nights of dancing and entertainment. Stories of its rise and fall still live on in island lore.

In 1905, the Put-in-Bay Improvement Company was established under the direction of Thomas Benton Alexander. Alexander, a world-famous

stage actor turned island investor and later hotel owner and mayor, served as the company's president. Henry Fox was named vice president, and Sahnke Johannsen served as secretary and treasurer. That fall, the company purchased the second Put-in-Bay House and the six acres of land it sat on from the estate of Valentine Doller, who had passed away in 1901. The cost of the property was placed at $20,000. At once, the company invested $50,000 in improvements.

At that same time, plans were unveiled to utilize the vacant corner of the property located at Catawba and Delaware Avenues. The site was previously occupied by the west end of the first Put-in-Bay House, which burned down in 1878. The second Put-in-Bay House was built a good distance away from the road, which left the corner open for future development. The Put-in-Bay Improvement Company announced that a large entertainment complex would be built on the site.

Ground was broken that October, and by February of the following year, the Feick Construction Company had started the work of framing in the building. By early May 1906, the building was nearing completion.

The new enterprise was officially called the Colonial Amusement Building but was also referred to as the Colonial Dancing Pavilion. In later years, it was just known as the Colonial. It was a two-story wooden structure that measured 116 feet along Catawba Avenue and 160 feet across the front on Delaware. Built in the Greek Revival style, the building featured two pediments, each supported by a pair of Doric columns and pilasters. In the center of each pediment were elegant Neoclassical scrollwork moldings. A massive domed pavilion that graced the corner was likewise supported by matching columns and pilasters. A second-story veranda measured 16 feet in width.

Located on the first floor of the Colonial was a fine buffet restaurant that served lunch. Like most other island establishments, it also had a café that served coffee and tea, soft drinks, ice cream and even ice cream floats, then called ice cream sodas. Cigars, liquor and other alcoholic beverages were available in the connected saloon. The restaurant, saloon and café all faced the central arcade, where various diversions were found. Souvenir stands and candy shops lined the walls, while games and Kinetoscopes were placed throughout the penny arcade.

The second floor boasted an eighteen-thousand-square-foot open dance hall. The space, which had no obstructing posts, was originally used exclusively for dancing. Music was provided by bands with upward of twenty members.

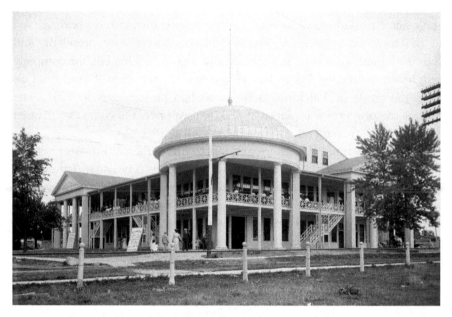

The new Colonial Amusement Building, circa 1906. *Library of Congress.*

The Colonial opened to the public with great fanfare on the evening of Saturday, June 16, 1906. The tables at the downstairs dining area were filled all weekend, while Finney's Orchestra from Detroit furnished the music upstairs in the dance hall. Its opening coincided with the start of operations of the new steam-driven electric power plant on the island, which was also built on the Put-in-Bay House grounds. This, too, was owned and operated by the Put-in-Bay Improvement Company. With its brilliantly lit buildings and streets, Put-in-Bay was finally entering the twentieth century.

On September 3, 1907, the nearby Put-in-Bay House was set ablaze by an arsonist. Thanks to the diligent efforts of the Put-in-Bay Volunteer Fire Department, the new Colonial was spared from the flames.

By the 1920s, the country had entered the Prohibition era, but this didn't seem to hurt business at the Colonial. While the saloon itself was closed, visitors still flocked to the second-floor dance hall every weekend, and the downstairs restaurant, arcade and café remained as popular as ever. It was also during the 1920s that an eight-lane bowling alley was installed at the west end of the first floor.

In 1941, the Colonial was sold to George and Fannie Lonz, who owned and operated Lonz Winery on Middle Bass Island. Not long after they purchased the facility, renovations were made and an extensive wine room

was installed. It was also at that time that the upstairs ballroom started seeing use as a roller-skating rink. For the next few decades, the restaurant and wine room continued to operate with few changes. In time, the place also offered bicycles for rent.

On March 12, 1964, Schnoor & Fuchs Grocery, which was located on the lot next to the Colonial on Catawba Avenue, burned down in the middle of the night. The Colonial was luckily spared again. Following the fire, the Schnoors put up a new building on their lot but farther away from the road than their grocery had been. They called that building the Villager and, from it, operated a bakery and hardware store.

In 1965, Allen Neff purchased the Colonial for $20,000 and spent the next two years extensively remodeling the building. He updated the bowling alleys with automated pin setters and added a billiard room. Al Neff also had the wine room converted into a new bar called the Bay 90's, which was styled to reminisce on the island's late 1800s history. In May 1968, the Island General Store, a grocery establishment, was opened in the Colonial. This replaced the Schnoor & Fuchs Grocery that had burned down four years earlier.

During the 1970s, management of the Island General Store was taken over by Eugene "Tip" Niese, who had extensive experience in the grocery industry. Not long after arriving at Put-in-Bay, he befriended two islanders named Skip Duggan and George Stoiber. The three men teamed up and purchased the Colonial from Allen Neff.

In 1979, Skip and George sold their interests to Tip, who soon after made some major changes. The bowling alley was removed and converted into a video game arcade. Meanwhile, the Bay 90's was renovated and reopened that year as the Beer Barrel Saloon. That spring, Tip hired on a relatively obscure but highly energetic entertainer named Pat Dailey. Dailey proved to be an instant hit with the crowds and for almost the next forty years played regularly at the bay. Being a mix of island and country, his sound impacted and forever changed the island's music scene.

All in all, the 1980s were shaping up to be an incredible success, as the first-rate entertainment was bringing in massive crowds to the Colonial. During the mid-1980s, Tip purchased the Villager and converted it into a restaurant that he called Papa Tippers. The spring of 1988 was looking to be the start of another amazing season, but that was not to be.

It was the beginning of the Memorial Day weekend, and the early holiday crowds were just starting to descend on the island. Shortly before 1:30 p.m. on the afternoon of Friday, May 27, a blast of fire erupted from an outdoor

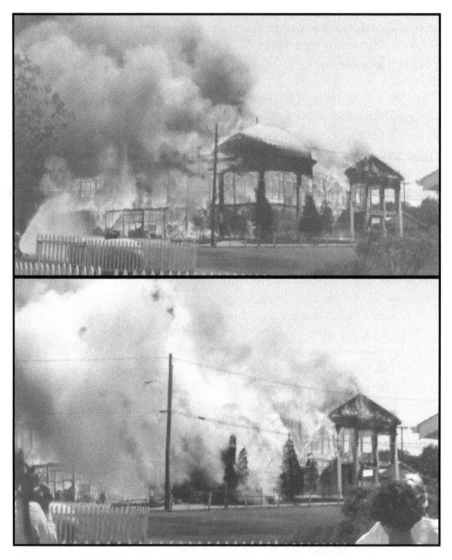

A fire consumed the Colonial on May 27, 1988. Caught on camera was the domed pavilion surrendering to the flames. *Courtesy Dan Savage and the Lake Erie Islands Historical Society Museum.*

barbecue grill located on the front patio of the Colonial. The girl who was attending the grill was injured by the flames but was moved to safety by another employee. Attempts at putting out the blaze were in vain, and a second blast worsened the situation. The fire quickly spread, and in no time at all, the building was engulfed.

It was evident almost at once that the Colonial was doomed. Within a few minutes, the volunteer fire department was on the scene, but massive flames were now racing through the eighty-two-year-old structure. All that could be done was to save the buildings around it. Nearby business owners were already spraying down their own buildings with garden hoses to prevent them from also falling to the blaze. The heat was so intense that the siding on neighboring buildings buckled and warped. Tar on nearby roofs bubbled up and sizzled. There was little for anyone to do but watch as years of memories blew away in a massive pillar of black smoke and ash that was seen for miles around.

The domed pavilion died with a crash, and in forty-five minutes, the Colonial was gone. Only a smoldering pile of burnt timbers remained. The Colonial was just getting ready for the start of a new season. Slated to play that evening was Pat Dailey, who later immortalized the events of the day in a song called "After the Fire."

Fortunately, Papa Tippers had been spared by the blaze. A makeshift grocery was set up there to replace the one that had burned with the Colonial. A few weeks later, the Colonial site was bulldozed and the debris cleared away. By Independence Day weekend, Tip had put up a massive party tent on the site, equipped with a bar and stage, and managed to pull off a season regardless of what had happened in May. That fall, the tent was taken down, and ground was broken for a new building.

The following year, the Beer Barrel Saloon opened to the public. It features seating for 1,200 guests and the world's longest bar, which measures 405 feet, 10 inches in length. Also located in the new building is Tippers Lounge & Restaurant. The building that previously operated as Papa Tippers was converted into the Island General Store.

HILL'S TAVERN

Located at Put-in-Bay is a house that, it has been claimed, dates to 1830. A sign out front states that it was built that year as a log cabin by Phillip Vroman. In the 1940s, it was restored by William Marks, who was married into the Vroman family. In 1998, it was added onto and converted into a bed-and-breakfast.

There's no doubt that this is the oldest house on the island, but much of the earlier information provided is a little skewed. In fact, it appears to

be much older than the sign claims. What's more is that this house has a deeper history than first thought. It turns out that it was originally called Hill's House and was even referred to as the Tavern of the Island. The story begins like this:

Daniel Hill was born around 1783 in Massachusetts. In 1808, he was married in New York to Lucretia Ogden, a daughter of John and Elizabeth Henderson Ogden. Lucretia was a relative of Frances Ogden, whose husband was Judge Pierpont Edwards, owner of the Lake Erie Islands.

Not long after their nuptials, Daniel and Lucretia Hill moved west to Detroit, where they were living at the outbreak of the War of 1812. When that town was attacked by the British under the command of General Proctor, Daniel Hill took up arms. With the surrender of Detroit, Daniel Hill was captured and held as a prisoner of war. He and a number of other prisoners taken at Detroit proved to be very troublesome for the British. Rather than execute them, these men were transported along the Canadian shoreline to the eastern end of Lake Erie, where they were released and sent back to the United States at the Niagara River. Per the terms of their parole, these men agreed not to take up arms against the British. As was commonplace for many other men who were forced to sign such agreements, Daniel Hill did not honor the terms.

While making his way back to Massachusetts, where he believed his wife and family would be waiting for him, Daniel Hill encountered Commodore Oliver Hazard Perry leading a line of about 150 men to Erie, Pennsylvania. The Hill family claims that Daniel enlisted with these men and marched west with them. It's stated that Daniel Hill served with Perry aboard his flagship, the U.S. brig *Lawrence*, at the Battle of Lake Erie.

The name Daniel Hill does not appear in the records pertaining to the Battle of Lake Erie, nor the Lake Erie squadron that fought it, but that is very easily explainable, as it doesn't seem likely that he would have used his real name. A man named Daniel *Hull* is listed among the men who marched west in February 1813 with Perry. He appears as the final entry on that list and is given the rank of "Boy," an entry-level position. He shows up later on the prize list from the Battle of Lake Erie as having served aboard the U.S. brig *Lawrence* under the name Daniel *Hall*. For his part in that action, he received $214.89, which was paid to him on September 25, 1814. He was afterward promoted to the rank of ordinary seaman and received his discharge from the navy on March 23, 1815.

It wasn't uncommon for men who had previously been captured by the enemy to enlist in the military under a pseudonym. Had they been recaptured

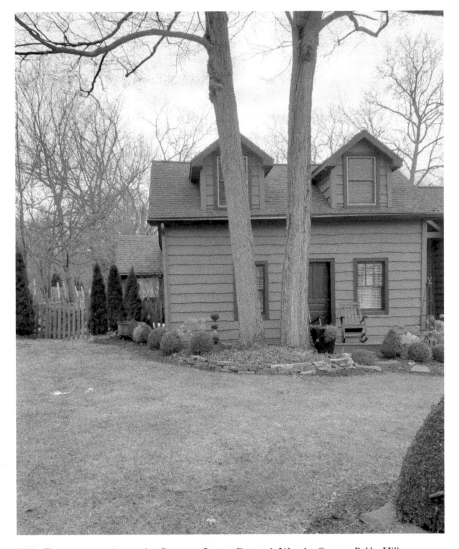

Hill's Tavern now exists as the Getaway Inn at Cooper's Woods. *Courtesy Bobby Hill.*

and their identity discovered, the punishment for breaking the terms of their parole was death. The fact that Daniel Hill shows up as the final entry on the list of men who marched west with Perry lends credence to the story that he joined up with these men while they were en route to Pennsylvania.

When the war had concluded in 1815 and Daniel Hill received his discharge from the navy that March, he sent for his family. Stories claim that Daniel recalled the beauty of the Lake Erie Islands from his time spent there

with Perry's Fleet and that this was what prompted him to move his family west. What's more likely is that he already knew of the islands through his wife's relation to Judge Edwards, who owned them. He was probably in communication with his wife and her family, and there was an agreement that they would move to the island to encourage resettlement.

Whatever the case may have been, the Hills moved to Ohio and settled at Put-in-Bay. A hand-hewn cedar cabin was soon erected in Edwards' Clearing about three hundred feet from the shore. There, Daniel and Lucretia Hill resumed their lives and laid the foundation for a future. The little cabin they had built served as more than just a simple home. It was also used as a rooming house and tavern, the island's first. Today, the site of this cabin is the southeast corner of Delaware and Catawba Avenues and is occupied by the Beer Barrel Saloon.

For the next decade, Daniel Hill worked the lake on his own vessel. Thus he came to be known as Captain Hill. Within the first year of settling at Put-in-Bay, Daniel and Lucretia were blessed by the birth of a son named James on May 16, 1816. James H. Hill has the distinction of being the first recorded birth at Put-in-Bay.

In 1817, James Ross, who had been the caretaker of the island, passed away and was buried on nearby Gibraltar Island. A new caretaker was needed. Rather than take on the role themselves, the Hills suggested an alternative.

In 1818, Henry and Sally Hyde of Rutland County, Vermont, traveled from New York to South Bass Island. Henry was born on May 15, 1785, to parents Jedediah and Elizabeth Brown Hyde. On January 22, 1806, he was married to Sarah "Sally" Hill, a daughter of John and Abigail Hill of Vermont. Though the connection cannot be confirmed, the strongest evidence points to Sally Hill Hyde being Captain Daniel Hill's cousin. Upon their arrival to the island, the Hydes took up residency with the Hills. Not long after, Henry and Sally managed to round up some of the hogs and sheep that were wildly roaming about and raised them in pens near the tavern.

Henry and Sally Hyde brought with them to the island their two daughters, Harriet and Sally, and sons Henry and George. Eight more children were born to them while at Put-in-Bay, though only five of them survived infancy. Meanwhile, Daniel and Lucretia Hill were blessed by the birth of a daughter in May 1821, whom they named Almira.

On July 20, 1821, the island was visited by Major Joseph Delafield, who at that time was conducting a survey of the U.S./Canadian border. He had

spent the earlier part of the day exploring Green Island, then called Strontian Island, and proceeded to South Bass Island that evening. He was given accommodations for the night at what he referred to in his diary as "Hills House, called the tavern of the island." He was given a clean sheet and spread his cloak over the bed, and his sleep that night was "tolerably comfortable."

Daniel Hill died quite suddenly during the first part of the summer of 1826. Early that August, his estate was settled by his widow and the administrators of his will. Lucretia Hill married another island settler named Horatio G. Haskins on August 29, 1826. Soon after, she received her late husband's land bounty from his service during the War of 1812. The bounty was for 160 acres in Columbus Township, St. Clair County, Michigan. At this, she left Put-in-Bay and relocated to that tract with her children and new husband. Daniel and Lucretia's son, James, rose to become one of Michigan's most noted lumbermen of the nineteenth century.

Henry and Sally Hyde continued to operate the house and tavern. A visitor to the island in 1829 wrote on the hospitality of the Hydes at their Put-in-Bay cabin:

The small boat took us on shore, where we knocked at the door of the only inhabitable cabin on the island. Knowing this family had resided here 12 years, we were astonished and delighted at the very friendly, urbane and graceful manner in which we were received by this hospitable and intelligent family....The evening passed off rapidly, with great hilarity.

Sally Hill Hyde passed away on November 11, 1830. Four years later, Henry left Put-in-Bay and ultimately settled in Portage Township, where he died in 1866 and was buried at Christy Chapel Cemetery. In 1836, the Manor House was built by Alfred Pierpont Edwards on the grounds adjacent to the former Hill's Tavern. During the years that followed, the cabin continued to see use as a home for various workers on the island.

The year 1843 saw the arrival of Phillip Vroman to Put-in-Bay. A biographical notice and the circumstances surrounding his arrival can be found in the first chapter of this book. Upon settling on South Bass Island, Vroman first resided near the current site of the village, but in 1846, he relocated to the south shore of the island, where he built a cedar cabin and cleared roughly one hundred acres for farming. That property later became the Anton Fuchs estate. His cedar cabin was located on the land immediately behind the modern house at 1657 Airline Road. A year after building his cabin, Phillip Vroman was married to Amelia Luce.

According to Phillip and Amelia Vroman's son Daniel, there were only five cabins on the island in the early 1850s. One was located on East Point. One was out where South Bass Island State Park is now located. There was, of course, the previously mentioned one on the south shore that was occupied by the Vromans. Two more cabins remained. One, originally occupied by Sheldon Johnson, was located close to where the Doller Building sits today. The last of these was the former Hill's House. It was this last building that the Vromans moved into in 1854. Daniel Vroman recalled in an account having moved with his family into that hewed log house near the Manor House. Not long after moving there, Daniel was afflicted with ague, a disease that exhibits malaria-like symptoms and was prevalent on the island at that time.

That same year, the islands were sold to Joseph de Rivera, and plans were put in motion almost at once to develop the area near the Manor House. On November 25, 1859, Phillip Vroman purchased from Joseph and Josephine de Rivera ninety-three acres of land for $3,000. The lot was bisected by present-day Langram Road and extended from Toledo Avenue west to Thompson Road. Over the next few years, Vroman divided that land and in turn sold it off. From the proceeds, he purchased property on Concord Avenue. It was upon making this later purchase that he moved the cabin, which he had been living in on the grounds of the Manor House for the last five years, to that new lot on Concord. He then set himself to the task of building a new frame house on the land adjoining it. That house was completed later in 1860. Today, it operates as English Pines Bed and Breakfast.

The best evidence suggests that the cedar cabin on Concord was unoccupied after the Vromans moved into their new house next door. The land that it sat on was largely undeveloped and, by the 1870s, was in the hands of the Delamater family. By the turn of the century, it was owned by a man named John Gangwich. Sometime during the early twentieth century, the cabin found its way back into the Vroman family. In 1944, it was fixed up by William and Erma Marks. Erma was the daughter of Phillip and Amelia Vroman's son George. At this time, the house was being referred to as the Marks' Cottage.

After changing hands a number of times and undergoing major renovations and additions, the house came into the possession of the Drake family in 2004. Located at 210 Concord Avenue, the house operates today as the Getaway Inn at Cooper's Woods.

Exposed hand-hewn logs in an upstairs bedroom (*top*) and tree trunk floor joists that still bear their bark (*bottom*) can be found inside the Getaway Inn. *Courtesy Sean William Koltiska.*

Details of the original cabin, which is the east section of the building closest to the road, can still be seen in that part of the house. The hand-hewed cedar logs that make up the cabin's walls are exposed in a room in the front of the house on the second floor. Likewise, the beams in the cellar are also hand-fashioned timbers. The floor joists are tree trunks, split in half, that still have their bark.

HYDE FAMILY CEMETERY

As stated in the last story, Henry and Sally Hyde came to Put-in-Bay in 1818. When they arrived at the island, they took up residency with Daniel and Lucretia Hill in their cedar cabin at Edwards' Clearing near the bay. The year before they moved to the island, Henry and Sally had a daughter named Clarissa, who died in infancy and was buried back in New York, where they had been living since 1809. A second daughter, Voluna, died in October 1814 at the age of three.

In all, Henry and Sally had fourteen children. Previously mentioned were their daughters Harriet and Sally and sons Henry and George. In January 1821, Sally gave birth to twin boys Edwards and Edwin. Sadly, Edwin died on September 3 of that year. As they were uncertain of where to lay the child to rest, a grassy spot was selected just to the east of the cabin.

Over the next seven years, Sally gave birth to four more children, those being Adison, Darwin, Volana and Rodney. In 1829, she gave birth to another child who didn't survive more than a day or two. That child was laid to rest beside Edwin. The following spring, Sally was again expecting, but at nearly forty-five years of age, there were complications. Sally Hill Hyde died in childbirth on November 11, 1830. She and her unnamed infant were interred in the small family cemetery near the cabin. Their graves were marked by a small tombstone. Four years later, Henry Hyde and his family left the island.

One who remembered that little burial ground quite well was Phillip and Amelia Vroman's son Daniel, who lived with his family in that cedar cabin formerly occupied by the Hydes and Hills. Daniel Vroman stated that between the cabin and the Manor House, which were only a few rods apart, was the grave of Henry Hyde's wife, who died and was buried there in 1830. He later recalled further details regarding that burial site:

The headstone for Sally Hill Hyde and her children now sits at Crown Hill Cemetery near the fence along Catawba Avenue. It's easily found opposite Joseph de Rivera's vault. *Photo by William G. Krejci.*

The Hyde family lived many years on Put-in-Bay. Mrs. H. and several of her children died and were buried on the grounds of which afterwards became part of the Put-in-Bay House property. As a child, I played about these graves, marked by a plain marble slab. This slab was in more recent years removed to the Put-in-Bay Cemetery, where it was given a prominent place near the main entrance, with fitting arrangements by the trustees.

It should be noted here that Daniel Vroman states that the headstone was given a prominent place near the cemetery's entrance, but the remains of Sally Hyde and her children were not. They still take their repose on that site in an unmarked location. Since the time of their burials, four major structures have been built on the site. Three of these have burned down.

FIRST ISLAND GRAVEYARD

Crown Hill Cemetery, near South Bass Island State Park, was established in the late 1850s. The first recorded burial there was that of Henry L. Foye, who died on December 7, 1859. It had long been said that a burial site predating it, other than the one for the Hyde family, existed somewhere on the island.

Theresa Thorndale, a writer for the *Sandusky Register*, penned an article on the island's early history in August 1892. For that article, she interviewed the island's longest-residing occupant, Phillip Vroman, who had been on the island for almost half a century. Vroman recalled many events, but it was his recollection of the forty-fifth anniversary of the Battle of Lake Erie in 1858 that struck a chord. The event was reported thus:

> *He was standing near the old willow when he observed in the crowd about him a man of worn and gristled appearance. His head was inclined and tears coursed slowly down his furrowed cheeks. Mr. Vroman kindly inquired as to the cause of his grief. The man lifted his head and pointed to the mound.*
>
> *"Here lie my comrades," said he. "Forty five years ago today we gathered at this spot to perform for them our last services. Since then I have not seen the place until now. Gazing once more upon it under circumstances so solemn and impressive, brings back a flood of recollections that overpowers me."*
>
> *In reply to inquiries, the old man gave some personal experiences of the battle. Said he:*
>
> *"I was with a large detachment of our men on the little rock island now known as Gibraltar when Barkley's fleet was first sighted approaching from the northwest. We lost no time in getting back to our vessels which were idly swinging at anchor. Orders from commanding officers were given quick and sharp. There was a great bustle of hasty preparation heard from deck to deck. Anchors were heaved and there was a great straining of blocks and cordage and a flap of canvas as the sails unfurled. Our fleet passed out of the bay between Peach Point and Middle Bass Island. The morning was as beautiful as any that I have ever seen. When about five miles north of Put-in-Bay we encountered the British squadron."*
>
> *After giving a description of the fight the narrator closed with an account of the burial of the dead at Put-in-Bay. According to his statement, six officers, three American and three British, were buried on the site marked by the willow, the marines and sailors on a beautiful, treeless knoll near Squaw Harbor.*

The article continued by stating that it had been previously claimed that the sailors and marines who fell in the action were buried at sea and sunk to the deep with a cannonball attached to their feet. Theresa Thorndale considered that this statement might now be in error.

It is a fact, though, that those enlisted men who were killed in the action were buried at sea in that manner. Every account backs this up. Still, the unnamed man was pressed by Phillip Vroman to show him where these marines and sailors were buried. He was led a little farther down the bay to the "treeless knoll." Theresa Thorndale continued:

> *The spot pointed out as the burial ground in question was afterward utilized by the early island settlers as a place of interment, and in excavating, human bones were unearthed, which goes to substantiate the statement as given above. Nearly all the remains of island settlers were finally removed to a tract of ground selected in after years as the present island cemetery. Green sward and vineyard sweep cover the site of the old burial ground at the present time and nothing is now left upon its surface to suggest the fact that it was ever used as such.*

The idea that a burial site was used in connection with Perry's Victory continued to surface in the occasional newspaper article. One from 1859 briefly mentioned a burial site "on the opposite side of the island near Squaw Harbor." It was alluded to again in 1894, when it was stated, "Farther down the island is a spot where more of Perry's men lie buried."

All in all, this created two great island mysteries. First, where exactly was this early cemetery located, and second, who was buried there?

Finally, in the early twentieth century, the cemetery's location was revealed. In his late years, Daniel Vroman wrote down another account of his long life spent on South Bass Island. He spoke at length about his childhood, moving into the village, friends that he had and his many adventures. Also included in this account was a mention of that first cemetery, which he explained was located in the front of Captain Dodge's home. He continued by saying that some of his schoolmates were buried there and some had been moved to Crown Hill Cemetery and that the old cemetery was a thing of the past.

Following the removal of the cemetery, or at least of those remains that could be located, the site sat vacant and unused. It was owned by John S. Gibbens, who had moved to the island around 1863. On October 13, 1867, John's youngest daughter, Ellen Rosina Gibbens, was married to James McDuff. Around 1870, John sold them the piece of land immediately to

the east of the house that he and his son Henry had just built that would, in the future, become the Bay View House. Almost at once, James and Ellen McDuff commenced construction of a new home on the site but set back, away from the road. It may well be that they were aware of the history of the site and decided it best not to build directly over the old cemetery. They moved into their new house around 1871.

Shortly before 1890, James and Ellen McDuff moved to Minnesota and sold their island home to a steamboat captain named Elliott James Dodge. Captain Dodge originally grew grapes on Middle Bass Island before entering the steamboat and fishing trade. He was noted for his heroic action in leading the rescue of three men from an overturned boat in 1906, for which he was awarded a gold medal. Today, the house operates as an island lodging called the Dodge House.

Now that the location of this cemetery had been discovered, the mystery of the identities of those buried at that site still needed to be solved. If the enlisted sailors and marines who were killed in the Battle of Lake Erie were buried at sea, how could the claim of them being buried on land also be true?

The site of the First Island Cemetery. *Courtesy Sean William Koltiska.*

Here's how.

On the morning of September 11, 1813, that being the day after the battle, the American squadron returned to Put-in-Bay from the battle site with the captured British in tow. The sick and wounded from both squadrons were transferred to the U.S. brig *Lawrence*, which was to be used as a medical transport. Ten more days passed before the *Lawrence* was able to sail back to Erie with those men who were wounded in the action. During the time that the *Lawrence* remained at Put-in-Bay, a number of men succumbed to their injuries. These are the sailors and marines who were buried on that treeless knoll.

Edward Martin enlisted in the navy as a seaman in New York on June 26, 1812. He was first attached to the USS *John Adams* but soon after marched west to Sackets Harbor. He arrived at Erie on July 18, 1813, and was assigned to the U.S. brig *Niagara*, where he was severely wounded at the Battle of Lake Erie. Seaman Martin died of his injuries soon after.

Ordinary Seaman William Davis arrived at Erie, Pennsylvania, in early August 1813. He had come with a number of men under Jesse Duncan Elliott, who had been sent from Sackets Harbor. Like Edward Martin, Davis served aboard the *Niagara*, was mortally wounded in the battle and died of his injuries the following day.

Joshua Trapnell was born in Baltimore, Maryland, in 1780. He was married on May 24, 1802, to Elizabeth Norwood. Joshua Trapnell enlisted as a private in Captain William Bradford's Company of the 17th U.S. Infantry. When a need for volunteers was realized, he offered his services from General Harrison's Army of the Northwest and served as a marine aboard the U.S. brig *Niagara*. During the action, he was severely wounded and died of his injuries shortly thereafter. His widow received a pension of $3.50 per month, as well as his prize money, which amounted to $214.89.

Francis Cummings served as an ordinary seaman aboard the U.S. brig *Lawrence*, where he was critically wounded in the legs. According to a journal kept by Dr. Usher Parsons, Francis Cummings died of sphacelus, or gangrene, of the lower extremities on Wednesday, September 15, 1813.

John Newen enlisted as a seaman in the navy at New York on April 28, 1812. He was dispatched to gunboat *No. 101* on May 12 and was promoted to quartermaster's mate. In February 1813, he was one of about 150 men who marched west with Commodore Perry to the Great Lakes. Promoted to quartermaster, John Newen was stationed aboard the U.S. brig *Lawrence* during the battle, where he was dangerously wounded in the head. Two days after the battle, Dr. Parsons performed a trepanation, a surgical

procedure where a hole is cut through the skull to the brain. During the surgery, Dr. Parsons removed a number of pieces of fractured skull, as well as a piece of the leather hat that Newen was wearing during the battle. Complications arose during the operation, and Dr. Parsons closed him up and dressed the wound. Quartermaster John Newen died of his injuries on September 17.

George Scoffield, who also appears on muster rolls under the names Schofield and Scofield, enlisted as a private in Captain Benjamin Mosby's Company of the 28th U.S. Infantry on May 5, 1813. He was transferred to Captain Joseph Belt's Company and was one of the men from General Harrison's army who volunteered to go aboard Perry's Fleet. Stationed aboard the U.S. brig *Niagara*, Scoffield served as a marine and was severely wounded in the action. He died on September 20, 1813, from injuries he sustained in the battle.

Laid to rest with these American sailors and marines were two men who served with the British fleet and died of their injuries following the Battle of Lake Erie. George Dogger, an ordinary seaman, was mortally wounded in the action aboard HMS *Detroit*. The name George Dogger turns out to be very uncommon. The only person matching his description was born in 1772 in a workhouse in Kent, England. These two may be one and the same.

The other man, William Bryan, was a private in the Royal Newfoundland Regiment of Fencible Infantry. He also served aboard HMS *Detroit* and died of his injuries shortly after the battle.

The site continued to see use for burial purposes after the *Lawrence* returned to Erie with the wounded. Other casualties followed through the fall, winter and well into the spring.

On September 24, 1813, a soldier from General Harrison's army, who tried to desert at Put-in-Bay, was put to death. The soldier had deserted twice prior to this and was sentenced to death on both occasions but had his sentences commuted. This being his third offense, the sentence of death was carried out. It was said that he faced his end with stoical indifference but that his execution had a lasting impression on the troops and discouraged further attempts at desertion. Two platoons fired on the soldier from a distance of five paces. His name is not divulged in the account.

John Rivir was born on May 12, 1780, in Somerset County, Pennsylvania, to parents John and Mary Lawson Rivir. Around 1807, he was living in Woodberry Township, where he was working as a miller. Within a year or two, he was married to Mary Winebrenner and started a family. During the winter of 1813, the Pennsylvania Militia was called up to defend the

shipbuilding operations at Erie. At this, John Rivir was made a private in Captain Isaac Linn's Company and marched north with the 147th Regiment under Colonel Rees Hill. Following the Battle of Lake Erie, a detachment of men from the 147th were sent to Cleveland to bring a number of smaller vessels to the islands for the invasion of Canada that took place later that September. According to family records and entries in a family Bible, John Rivir died at Put-in-Bay on October 18, 1813, and was "buried on Bass Island in the State of Ohio."

It's unknown what John Rivir's cause of death was, but it may have been from some mishap, as another private from that same company died on the exact same day. Alexander Laughlin was born in 1772 in Fayette County, Pennsylvania, to parents Hugh and Mary Ann Breading Laughlin. In 1793, he was married to Elizabeth Brashear and started a family. Like John Rivir, he was called up with the Pennsylvania Militia and was made a private in Captain Isaac Linn's Company. Having also died at Put-in-Bay on the same day, he would have been buried alongside Private Rivir.

Simon Warn, who appears in some records as Simeon Warne, was born on March 20, 1792, in Schenectady, New York, to parents Samuel Warne and Catharina Van Antwerp. He first served as a captain's clerk under Jesse Duncan Elliott at Sackets Harbor, being attached to the U.S. sloop *Madison*, then the USS *General Pike*. In August 1813, he accompanied Elliott and his men to Erie and served as a midshipman aboard the U.S. brig *Niagara* at the Battle of Lake Erie. After having returned with the squadron to Erie that October, he was dispatched with Lieutenant John Packett that winter and arrived at Put-in-Bay in February. Midshipman Simon Warn died at Put-in-Bay on February 22, 1814.

Luther Palmer was a son of John and Miriam Osborne Palmer of Poquonock, Connecticut. He was raised in Sunbury, Monroe County, Ohio, where his family settled in the 1780s. Around 1810, he relocated to Worthington, Franklin County, and was living there at the outbreak of the War of 1812. He enlisted in the army on April 29, 1813, as a private in Captain George Sanderson's Company of the 27th Regiment, commanded by Colonel George Paul. That regiment saw action at the Defense of Fort Stephenson, in present-day Fremont, and at the Battle of the Thames, where Tecumseh fell. According to the muster rolls from December 3, 1813, Private Luther Palmer was listed as being sick at Put-in-Bay. He died there from illness on March 12, 1814. Luther Palmer made out a short will just before he died and left his estate to his sister Miriam and brother Ethan. He also referenced his brother Benjamin, who was living in Connecticut.

A previous will had been written on May 11, 1813, which left everything to Benjamin. Luther Palmer was unwed and had no children.

William Kilgore was born on December 31, 1774, in York County, Pennsylvania, to parents Matthew and Martha Mary Cunningham Kilgore. Around 1800, he made his way west and settled in Ross County, Ohio, where he was married to Margaret Sample Cochran on July 22, 1802. When war was declared ten years later, William Kilgore joined Renick's Regiment of the Ohio Militia and was made a captain. During the winter and spring of 1814, he was among the men stationed at Put-in-Bay, where he died and was laid to rest on April 14, 1814. In 2013, an online memorial was created for him that claims he's interred at the Old Burying Ground in Greenfield, Highland County, Ohio. Burial records show, however, that only his son Matthew is buried there. Captain Kilgore still takes his repose on South Bass Island.

The Lake Erie squadron and the U.S. Army departed Put-in-Bay in the spring of 1814 and left the little burying ground behind as a small reminder of what had befallen their company throughout that difficult winter on the desolate Lake Erie island. Twelve more years would pass before the tiny graveyard received another burial.

It's pointed out in the 1892 article by Theresa Thorndale that the location of the military burial ground was afterward utilized by early settlers as a place of interment. This indicates that someone on the island must have known the site to have previously been used for burial purposes. The only person in those years of island settlement—other than James Ross, who died in 1817—was Captain Daniel Hill. It stands to reason then that Captain Hill, upon his death in the summer of 1826, would wish to have his body take its repose among the bones of his fallen comrades in arms. Thus, the site found use again as an active cemetery.

Daniel Vroman mentioned in his account that some of his schoolmates were buried in that first island cemetery. Unfortunately, after extensive research, their names could not be located. There are, however, a number of others who died in the years after Daniel Hill and also found their repose on that site. Their names have now been rediscovered.

George McGibbon was born in Scotland around 1790. By the 1830s, he and his wife, Helen, were residing at Put-in-Bay. Both of their names appear in a ledger kept by Philip Van Rensselaer, who operated a store and trading post on the island. In June 1838, Helen's name appears but then is crossed out and does not appear again. It's believed that she died about this time and was laid to rest in the island cemetery. Her husband, Captain

George McGibbon, passed away sometime after 1850 and was laid to rest beside her.

Clarissa Ann Moe was born in Ohio on February 10, 1830, to parents Isaac and Angelica Rhoda Moon Moe. By 1850, the family was living in Danbury Township. Clarissa Moe was married at Put-in-Bay to George W. Hinger on September 15, 1852. She died and was buried there in 1855.

Maria A. Caldwell was born at Put-in-Bay on March 28, 1856, to parents Charles and Barbara Fox Caldwell. Less than a month later, she passed away and was laid to rest in the little island burial ground. With the establishment of Crown Hill Cemetery, her remains were relocated there, where her one-year-old brother Edward was interred in August 1862. Their remains were relocated some years later to Maple Leaf Cemetery, where their headstone may be found today.

Adding the unnamed schoolmates of Daniel Vroman who were once buried at that location brings the total number of burials to well over twenty. When the original cemetery was disinterred in the late 1850s, the majority of the graves that could be located were exhumed and reinterred in the Potter's Field section of Crown Hill Cemetery. That area exists today as the open, grassy area directly in front of Joseph de Rivera's vault near Catawba Avenue. The original cemetery site remains unmarked.

FINAL THOUGHTS

Obviously, these are but a few of the countless stories from Put-in-Bay's extraordinary past. Looking back, we've rediscovered an early island history long forgotten. We've visited stately guest accommodations. We've sailed aboard steamers, ridden on roller coasters and trolleys and delved into mysterious caves from a time long ago. We've explored the village of yesterday and met a number of its citizens. We've done all of this, if only in our minds.

Looking forward, we must consider all that we have now that will one day become a thing of the past. If we've learned anything here, it's that we shouldn't take any of it for granted. We should enjoy what we have while we can, while it's still here, before it, too, becomes lost.

BIBLIOGRAPHY

Altoff, Gerard T. *Deep Water Sailors, Shallow Water Soldiers*. Put-in-Bay, OH: Perry Group, 1993.

———. *Oliver Hazard Perry and the Battle of Lake Erie*. Put-in-Bay, OH: Perry Group, 1999.

American Lumberman, 1906.

American Telegraph (Washington, D.C.), June 4, 1817.

Anderson, Isaac. *Journal*. 1781.

Ann Arbor Daily Times, July 18, 1906.

Annual Report of the State Fire Marshal to the Governor of the State of Ohio. Ohio Division of State Fire Marshal, 1908.

Ariel (Natchez, MS), May 4, 1827.

Bay City [MI] Times, 1932–33.

Beers, J.H. *Commemorative Biographical Record of the Counties of Huron and Lorain, Ohio*. Huron County, OH: J.H. Beers, 1894.

———. *Commemorative Biographical Record of the Counties of Sandusky and Ottawa, Ohio*. Chicago: J.H. Beers, 1896.

Boston Semi-Weekly Atlas, February 20, 1847.

Boston Traveler, August 27, 1839.

Celina [OH] Democrat, July 3, 1914.

Chronicle Telegram (Elyria, OH), 1958–91.

Cincinnati Commercial Tribune, June 1, 1890.

Cincinnati Daily Enquirer, 1870–74.

Cincinnati Daily Gazette, 1868–78.

Cincinnati Literary Gazette, January 1, 1824.

Cincinnati Post, 1894–1905.

Cleveland Gazette, July 11, 1914.

Cleveland Herald, 1852–53.

Cleveland Leader, 1858–1903.

Cleveland Plain Dealer, 1842–1999.

Columbus Dispatch, 1871–1980.

Commercial Advertiser (New York), February 17, 1813.

commons.wikimedia.org.

Connecticut Herald, June 28, 1836.

Cooper, Susie. *Crown Hill Cemetery*. Put-in-Bay, OH: Lake Erie Islands Historical Society, 2010.

Coshocton [OH] Tribune, August 28, 1960.

Daily Cleveland Herald, February–June 1875.

Daily Commercial Register (Sandusky, OH), 1848–67.

Daily Jeffersonian (Cambridge, OH), 1914–53.

Daily National Intelligencer (Washington, D.C.), August 2, 1819.

Daily Ohio Statesman (Columbus, OH), July 26, 1859.

Darby, William. *A Tour from the City of New York to Detroit*. New York: Kirk & Mercein, 1819.

Delafield, Joseph. *The Unfortified Boundary: A Diary of the First Survey of the Canadian Boundary Line from St. Regis to the Lake of the Woods*. Madison: University of Wisconsin, 1943.

DeLuca, Helen R. *The Lake Erie Isles and How They Got Their Names*. N.p.: Historic Lyme Church Association, 1974.

Democratic Press (Ravenna, OH), October 3, 1894.

Detroit Times, 1908–31.

Disturnell, J. *The Great Lakes or Inland Seas of America*. Philadelphia: W.B. Zieber, 1871.

Dodge, Robert J. *Isolated Splendor: Put-in-Bay and South Bass Island*. Hicksville, NY: Exposition Press, 1975.

Elyria [OH] Chronicle, June 21, 1907.

Elyria [OH] Evening Telegram, 1912–15.

Erie [PA] Times-News, October 23, 1907.

Evening Star (Washington, D.C.), August 24, 1932.

Flag of Our Union (Boston), August 20, 1853.

Fredriksen, John C. *Surgeon of the Lakes: The Diary of Dr. Usher Parsons 1812–1814*. Erie, PA: Erie County Historical Society, 2000.

Fremont Journal, May 4, 1866.

Fremont Weekly Journal, June 18, 1869.

Frohman, Charles E. *Put-in-Bay: Its History.* Columbus: Ohio Historical Society, 1971.

Gibson, John, and Thomas Posey. *Governors Messages and Letters of William Henry Harrison.* Indianapolis: Indiana Historical Commission, 1922.

Goodman, H.J. *Illustrated Historical Atlas of Ottawa County, Ohio.* Port Clinton, OH: H.J. Goodman LL.D., 1900.

Gora, Michael. *Lake Erie Islands: Sketches and Stories of the First Century After the Battle of Lake Erie.* Put-in-Bay, OH: Lake Erie Islands Historical Society, 2004.

Greenville [OH] Journal, June 11, 1914.

Hamilton [OH] Evening Journal, July 15, 1931.

Hardesty, L.Q. *Illustrated Historical Atlas of Ottawa County, Ohio: From Recent and Actual Surveys and Records.* Chicago: H.H. Hardesty, 1874.

Hotchkiss, George W. *History of the Lumber and Forest Industry of the Northwest.* Chicago: George W. Hotchkiss & Co., 1898.

Huron [OH] Reflector, 1834–36.

Indianapolis Journal, July 16, 1894.

Indianapolis News, August 15, 1903.

James, William. *A Full and Correct Account of the Military Occurrences of the Late War between Great Britain and the United States of America.* London: printed by the author, 1818.

Krecker, Frederick Hartzler. *Periodic Oscillations in Lake Erie.* Columbus: The Ohio State University Press, 1928.

Lake Erie Islands Historical Society. *Put-in-Bay Souvenir Tour Book.* Put-in-Bay, OH: Lake Erie Islands Historical Society, 2010.

Langlois, Thomas Huxley, and Marina Holmes Langlois. *South Bass Island and Islanders.* Columbus: Ohio State University, 1948.

Ligibel, Ted, and Richard Wright. *Island Heritage: A Guided Tour to Lake Erie's Bass Islands.* Columbus: Ohio State University Press, 1987.

Lossing, Benson J. *The Pictorial Field-Book of the War of 1812.* New York: Harper & Brothers Publishers, 1869.

Martin, Jessie A. *Beginnings and Tales of the Lake Erie Islands.* Detroit: Harlow Press, 1990.

Michigan Farmer, July 15, 1911.

Milwaukee Journal, December 11, 1932.

Moizuk, Ruth Dickerman. *The Put-in-Bay Story Told from Top-of-the-Rock.* Put-in-Bay, OH: R.D. Moizuk. 1968.

Newark [OH] Advocate, July 14, 1951.

Newell, Amy L. *The Caves of Put-in-Bay*. Put-in-Bay, OH: Lake Erie Originals, 1995.

News Herald (Port Clinton, OH), 1975–80.

New York Herald, March 18, 1896.

New York Spectator, November 20, 1829.

Nunan, Philip. *Map of Erie & Part of Ottawa Counties, Ohio*. Sandusky, OH: Philip Nunan, 1863.

Ohio Farmer (Cleveland, OH), 1859–67.

Ohio State Journal, 1839–59.

Ottawa County News (Port Clinton, OH), 1952–54.

Perrysburg [OH] Journal, September 18, 1903.

Pittsfield [MA] Sun, September 6, 1849.

Poughkeepsie [NY] Journal, July 26, 1845.

Put-in-Bay Gazette: Colonial Edition, May 1993.

Reporter (Brattleboro, VT), October 31, 1815.

Repository (Canton, OH), 1890–1980.

Republican Farmer (Bridgeport, CT), August 14, 1816.

Ryall, Lydia Jane. *Sketches and Stories of the Lake Erie Islands*. Perry Centennial Edition. Norwalk, OH: American Publishers, 1913.

Saginaw [MI] News, June 20, 1882.

Sandusky [OH] Clarion, 1826–47.

Sandusky [OH] Daily Register, 1873–92.

Sandusky [OH] Daily Star, May 21, 1901.

Sandusky [OH] Evening Star, September 5, 1902.

Sandusky [OH] Register, 1894–1939.

Sandusky [OH] Star, 1899–1900.

Sandusky [OH] Star Journal, 1902–20.

Severance, Frank H. *Publication of the Buffalo Historical Society*. Buffalo, NY: Buffalo Historical Society, 1905.

Smith, Colonel James, and William M. Darlington. *An Account of the Remarkable Occurrences in the Life and Travels of Col. James Smith*. Cincinnati, OH: Robert Clarke & Co., 1870.

Spectator (New York), November 20, 1929.

Star Journal (Sandusky, OH), August 31, 1921.

Steubenville [OH] Herald, July 12, 1816.

Thorndale, Theresa. *Sketches and Stories of the Lake Erie Islands*. Sandusky, OH: I.F. Mack & Brother, 1898.

Tiffin [OH] Weekly Tribune, May 3, 1866.

Toledo [OH] Union Journal, June 4, 1948.

U.S. Steamboat Inspection Service. *Annual Report of the Supervising Inspector General*. Washington, D.C.: U.S. Government Printing Office, 1904.

U.S. Topographical Bureau. *Kelley's and Bass Islands: Showing the Harbors of Refuge in Their Vicinity*. Washington, D.C.: War Department, 1849.

White, George Willard. *The Limestone Caves and Caverns of Ohio*. Columbus: The Ohio State University, 1925.

Williams Brothers. *History of Lorain County, Ohio*. Philadelphia: Williams Brothers, 1879.

Williams, William W. *History of the Fire Lands*. Madison, WI: Press of Leader Publishing, 1879.

www.ancestry.com.

www.carriagehousepib.com.

www.findagrave.com.

www.fold3.com.

www.genealogybank.com.

www.greatlakes.bgsu.edu.

www.historicdetroit.org.

www.loc.gov.

www.ohioseagrant.osu.edu.

www.opencorporates.com.

www.thehenryford.org.

ABOUT THE AUTHOR

William G. Krejci was born in Cleveland, Ohio, in 1975 and raised in the neighboring suburb of Avon Lake. With an interest in local history, he spends much of his time debunking urban legends and is the resident historian at the Franklin Castle. He is the author of *Buried Beneath Cleveland: Lost Cemeteries of Cuyahoga County*, *Haunted Put-in-Bay* and *Ghosts and Legends of Northern Ohio*. He is also the coauthor of *Haunted Franklin Castle* and author of the *Jack Sullivan Mysteries*. He's been a guest speaker at many local historical societies, libraries, bookstores and civic group meetings. He has appeared as a guest on multiple national television programs on the paranormal and has been featured on many local television and radio programs. He is also the co-host of the Haunted Put-in-Bay Ghost Walk. In his free time, he sings and plays guitar in an Irish band.

Visit us at
www.historypress.com

Lightning Source UK Ltd.
Milton Keynes UK
UKHW020220100522
402745UK00005B/42